Everything a Marketer Needs to Know About Film and Photography

The Marketer's Guide
to Creative Production

Jillian Gibbs

Why triple bid?
Who are these people?
Is this the right Director?
Should I attend the shoot?
When can I make changes?
Do I have to pay for that?
How do I future-proof my content?

Everything a Marketer Needs to Know About Film and Photography

The Marketer's Guide to Creative Production

Jillian Gibbs

The Marketer's Guide to Creative Production:
Everything a Marketer Needs to Know About Film and Photography

For information about this title or to order other books and/or electronic media, contact the publisher:

Redhead Enterprises, LLC
www.creativeproductionformarketers.com

ISBNs:
979-8-9877515-0-3 (softcover)
979-8-9877515-1-0 (eBook)

Printed in the United States of America

Cover and Interior design: David Dye

To the many people who work in the advertising industry, I have no hidden agenda here. I hope this book helps to ground you in the fundamentals necessary to make great content with great people to get optimal results.

To my brother, Thomas, who was my biggest fan.
"Look it here, I made a book!"

ACKNOWLEDGMENTS
by Jillian Gibbs

Accolades and appreciation to my amazing team of subject-matter experts at Advertising Production Resources (APR), with whom I've worked with for more than 20 years to help marketers work efficiently and effectively while producing their creative content.

A special thank you to Alan Sadler, Carol Pock, Ron Hacohen, Kirsty Dye, and Lori Estabrooks for reading the entire book, cover to cover, to help me refine and pinpoint the stories and explanations.

To Lori and Kirsty for also helping to ensure that the book is written for marketers working or shooting in any country around the world, especially Canada and the UK.

To Susan Kurtz and Marie Schroeder for the visual effects, virtual production, and post-production details.

To Kathy Keith, our historian at APR, and to Becky Robinson, for facilitating the book process, without whom I couldn't have made this happen.

To Dave Dye, a world-renowned agency creative director, for his fabulous illustrations and honest quotes, which help to validate the teachings in the book—especially that agencies need great briefs to be great agencies.

To those who gave the book a pre-read and provided feedback to ensure it would resonate strongly with their teams on the marketing side. And to the agency and production leaders who care

about quality creative and effective process as much as I do, I thank you for your thoughtful contributions.

It does take a village to do great work, and, as this is my life's work and the foundation for my business at APR, I appreciate the collective who contributed to this book and who share in the vision to positively influence the marketing-production industry.

CONTENTS

FOREWORD xi

INTRODUCTION BY THE AUTHOR xv

WHY THIS BOOK? xvii
Who Should Read This Book? xvii
What Is *Not* Included? xx

LET'S BEGIN 1
The Landscape 1
So, What Do We Do About It? 4

CONTENT-CREATION PRODUCTION PROCESS 11

PLANNING 15
Planning for All Media 15

PRODUCTION 33
Buying Production and the Bidding Process 33
Preparing for Your Production 49
Production: At the Shoot 58
First Time on Set? No Sweat! 60
Setiquette (On-set Etiquette) 63
Set Safety 65
Post-Production 71

DELIVERY 81
Delivery: Trafficking 81
Job Wrap/Reconciliation 82

COST DRIVERS/TRAITS 83

THE MARKETER'S BILL OF RIGHTS 91

SPECIAL CONSIDERATIONS: 95
Why Are There So Many Producers
On My Production? 95
Audio and Music Production 97
Talent Overview 100
Augmented Reality/Virtual Reality (AR/VR) Production 104
Virtual Production 107
Centralizing Usage-Rights Management 111
Tax Incentive Locations 115

FOR THE MARKETING LEADER 119
Decision-Making and Your Influence 119
Marketing Leadership as a Driver for Social Change 121

APPENDIX 129
Sample Agendas for Key Production Meetings 129
Offline Edit Review Meeting (Post-Production) 142
Post-Mortem Meeting Agenda 144

ABOUT THE AUTHOR 151

FOREWORD

The Marketer's Guide to Creative Production is definitely the first book of its kind. Having spent my entire 28-year career in the Advertising/Commercial Production industry, there has never been a road map that guides executives from three distinctly different industries through the process of collaborating toward the mutual goal of successful content creation. And this one is spot on!

Until you find yourself in any one of the many situations described in Jillian Gibbs's book, you simply don't know what it's like or what to do. And if you do know what to do, most people don't know *how* to do it, and the consequences can be devastating. This book walks you through the process. It breaks down all of the things people take for granted about how the process works—things that many people involved in the content-creation process assume someone else will handle. Her book clearly spells out everyone's role. Her clearly explained structure of "who does what, when, how and why" is *long* overdue. Pre-planning and role identification, at all stages of a marketer's commitment to the content-creation process, is essential. Thankfully, someone has finally laid it all out succinctly and accurately!

—JONATHAN WEINSTEIN, Professor, NYU Tisch School of the Arts, Undergraduate Film Dept, Founder & Executive Producer Go Films Inc.

It is important that advertisers get value from production; it is what they are entitled to and the best encouragement to make more advertising content. Jillian uses her vast experience to help advertisers understand how to get value and the preparation and organization they need internally—as well as from the agencies and production companies they work with—to achieve that. In doing so, Jillian has created an invaluable guide to production.

—STEVE DAVIES, Chief Executive, Advertising Producers Association in the UK

The thoroughness and attention to detail is excellent. This book is a thorough guide for ensuring a smart and thoughtful approach to production [so that] you and your team are set up for clarity and success throughout the process.

—CAROL HUTCHINSON, General Manager, Global Advertising

Production is the "last mile" of creative development—and is the means to bring ideas to life. Exactly how they are brought to life is the result of the people and processes involved. This book provides a rich assortment of examples, tips, and best practices to help marketers optimize their productions, leading to the best creative possible to ideally drive the strongest business results.

—BILL DUGGAN, Group EVP, Association for National Advertisers

This is the first book that captures the essence of advertising production best practices. It will be an evergreen reference to train agency producers and a much-needed way to bring together marketers, agencies, and the production community.

—SERGIO LOPEZ FERRERO, Global Head of Production, Publicis Groupe

There is no better production tool than experience, judgment, taste, and understanding. And if time, indeed, equals money, the best way to leverage financial resources is to work smarter and more efficiently. Jillian Gibbs's *The Marketer's Guide to Creative Production* helps make any reader, be it a marketer, an agency partner, or a production partner better prepared and able to contribute in their role. As someone who has spent half of my career working at agencies and the other half as a production partner to some of the country's smartest and most prolific marketers, working on everything from dozens of Super Bowl® spots to content filmed on my phone, I recommend this guide as essential reading. We make better work and create a higher return on a production investment the better educated we are. We will save more money by working smarter than we can by any other action. Simply put, reading this

will help you feel more confident during the production process, no matter how many hours you've logged on set.

—ADAM ISIDORE, Award Winning Executive Producer and Production Lead previously at FCB, BBDO, and The Mill

With the coming of AI, creative production will be even more critical—Jillian has written the book to guide you.

—SIR MARTIN SORRELL, Founder & Executive Chairman, S4 Capital

Jillian and I worked together for about ten years (1997-2007) when she was in-house Production Consultant at Coors Brewing Company and I was Head of Production for Tool of North America. While production companies often see Production Consultants as an "us against them" battle, Jillian shattered this perception by introducing a transformative, collaborative approach to redefine the narrative as "we" are in this together to find solutions. Embracing the power of creative partnership, she consistently sought to educate and invited us to hear more about what was going on with the marketers. With Jillian's wealth of firsthand knowledge, "The Marketer's Guide to Creative Production" will help Marketers to navigate all the many steps and nuances of video production and assist production companies (and the people who work there) to better understand the Marketer's perspective in production.

—JENNIFER SIEGEL, Managing Director, Framestore Pictures

Intro
by
author

INTRODUCTION
by the Author

I started my career in New York City, where I was born and raised, working at a few ad agencies before taking a job at Lever Brothers (now Unilever, one of the largest consumer-products companies in the world). I supported and reported to my mentor, Al Tennyson, the head of production of Chesebrough-Ponds, Lipton, Ragu, Van den Berg Foods, and Lever Brothers. Al took me under his wing and mentored me until he retired, and, at 25 years old, I became the production supervisor at Unilever from 1989 to 1997. I married and moved to Colorado, took a consulting role at Coors Brewing Company (now Molson Coors) as their production consultant and, soon after, set up a consultancy to be able to support many marketing departments across Fortune 500, national, and multi-national companies. As of this writing, APR Consulting, also known as Advertising Production Resources, is the largest and most influential production consultancy in the world, located in 42 countries, and advising more than 75 of the world's leading marketers. As an entrepreneur and founder of APR, I have experienced growth as a person and as a company. I have been told that I have made an important impact on the advertising industry. I am truly grateful for this 20-plus-year journey that has yielded much learning, recognition, and contribution, as well as many rewards, both personally and professionally.

The inspiration for this book came while I was teaching a master class for the Association of National Advertisers (ANA) on Creative Production. I have been an ANA Faculty Member since 2009, and many ANA workshop attendees have recommended that I put the basics of production, including how to make the most of shooting original content, into a book format. Given the competing priorities today, including the need for more content, rising production costs, and the necessity to do more with less, the timing could not be better. And, so here we are. I hope this book is helpful to those marketers and other stakeholders who are seeking to contribute effectively and efficiently to the creative-production process and get great work out of their creative and production teams.

OLDEN DAYS

LOVEY DOVEY STORIES

TALES OF POND LIFE

Why this book?

KEVIN LE FROG

MADE-UP FACTS

YE OLDE WEB DATA

HOW TO BE NICE

WHY THIS BOOK?

When I started in the advertising industry in the late 1990s, there was a book, written by Miner Raymond, called *Advertising That Sells: A Primer for Product Managers*, about the creative-development and advertising-production processes. It focused on the production of print ads and TV commercials. Miner came from the world of Procter & Gamble (P&G), and, in the 1980s, he started one of the original advertising production cost-consulting companies in the USA. Miner has long since retired, and his book is out of print, but I still cherish the two copies on my bookshelf and have often lent them out to colleagues when they first join my company. Many of the principles for effective creative production that are found in Miner's book still hold true for the creative-development and production processes today, such as the art of storytelling, brand-building principles, and developing campaigns with three or more ads. Yet today, the vehicles, platforms, budgets, and types of production approaches have all since evolved, and this book addresses the basics of production.

This book has been written to help clarify how to approach content creation efficiently and effectively. It is meant to fill a gap in the marketing and advertising industries, where training is lacking.

Who Should Read This Book?

This book is a pocket guide for marketers, marketing-procurement specialists, marketing-operations and business-affairs professionals, and in-house client-side producers who want to better understand the creative-production process as it relates to creating marketing and advertising content for video or photography, including moving images, motion footage, and stills, aka

photographs. The great thing is that, no matter what type of content is being produced, the best practices, learnings, and questions to ask can be applied around the world because the production process is basically the same everywhere. The production crews and talent work very similarly, which is why it is pretty easy to travel the world to shoot and work in different countries.

This book does not focus on big-picture strategy for the CMO or marketing leader. Instead, it narrows in on the production process from production planning, to creative approvals, to getting finished assets to use in the market.

In today's fast-paced and evolving creative-marketing industry, there can be many creators, from influencers to Super Bowl® directors using a variety of approaches to produce content. It is important for marketers to have a better understanding of the risks, take more control of the management of content creation, and deliver great creative efficiently and effectively.

After reading this book, you will:

1. Understand the production process and how to prepare for—and get the most out of—your live-action or photography shoot.

2. Learn how to get the most out of your creative and production partners for optimal production values and creative quality.

3. Gain confidence in your decision-making during the production process by asking the right questions at the right time.

4. Learn about the drivers and optimizers that can impact production costs and how you may unknowingly affect them.

For Marketers

Within these pages, you will be given the tools to take responsibility for using tried-and-true production practices to achieve high-quality creative with appropriate partners and resources.

Your creative options are endless, however, the fundamentals for shooting and editing remain constant and are the foundation of great storytelling.

Understanding how content is made will help tell your stories effectively and efficiently. This guide can be invaluable in getting the most out of the creative-production process for you, your team, and your creative-production resources.

For Marketing Procurement/Sourcing Professionals/Marketing Operations/ Business Affairs

For sourcing, procurement, operations, and business-affairs professionals who support their marketing teams by managing creative and production partnerships and budgets, this book is your guide to contributing to the creative-production process effectively, as this book covers all the considerations that go into producing superior content. You'll have the tools to navigate the production landscape and understand the cost drivers and optimizers affecting the creative process to best support your marketing teams.

Pro Tip:
"Marketing Operations and Procurement can help create the infrastructure needed to support a marketing organization that is evolving and wants to experiment with new production models and suppliers." (Jillian Gibbs, WFA ProcureCon Conference, Lisbon, Portugal, 2019)

What Is Not Included?

Since the purpose of this book is to be evergreen and serve as a guide for content production shot around the world, global rates and specific regional/local nuances have been omitted. This book is intended to make you a more informed marketer, *not* to make you a subject-matter expert in production.

For more information or a deeper dive into any of the topics included in this book, you can access APR resources at www.aprco.com, including:

▸ APR's Global Campus Webinars and Training

▸ APR's Production Concierge® services

 · Giving you access to APR's knowledge base and subject-matter experts in many areas of production that were too numerous to include in this book, such as digital development (OLA, microsites, app development), social media production, digital video, experiential and events, etc.

▸ The APR Index®, APR's interpretation of industry benchmarks and production data

Please note, we aim to keep this as a pocket guide, not an exhaustive encyclopedia.

Terminology Clarifications: We realize that each project and organization is unique, and roles may be filled differently depending on your production approach and partners. Some of these terms may be used interchangeably throughout the book:

▸ **Marketers**: marketers or advertisers funding the production

▸ **Creative Team**: external agency, in-house content studio on the client side, and third-party creatives creating the ideas

▸ **Producer**: running the production on behalf of the marketers, such as the creative-production partner, agency producer, or in-house producer

▸ **Suppliers**: all companies, vendors, partners who are working in concert to produce a marketer's assets

Need to Know: At the end of each chapter, you will find a checklist of "Need to Know" items. These are a summary of best practices and key takeaways for your convenience.

"Zip...erdi...doo...dah..."

Let's begin

LET'S BEGIN
The Landscape

The traditional advertising landscape, which relied solely on the 30-second TV commercial, has vanished. The world of content production has become fragmented, complex, multi-layered, and far too integrated for a single commercial to meet the consumer where they are. Additionally, most marketers rely on more than one advertising agency to effectively manage all the various, often competing, elements of a marketing campaign.

Much has changed in the last 10 years, and at the time of this writing,

▸ The lines between an agency and a production company are blurring, as both are creating the ideas and producing the assets.

▸ Large consulting firms have become both the auditor of marketing transformation and the solutions provider for brand-marketing teams. (You can think of them as being both the coach and the player, which can create a conflict of interest.)

▸ The silos and lack of transparency into media, creative, and production spend create confusion and inefficiencies.

▸ Agencies have eliminated their training and mentoring programs for producers and business-affairs professionals.

As a result of these factors, optimization of how content is produced is more complex today than ever before, and learning new methods of production is harder than ever, but necessary.

Given the speed at which the industry is changing, careful attention must be given to operationalizing a faster, better, more-efficient way of working. It is one of the reasons that advertisers are building media, creative, and production capabilities internally to take back more control and optimize their investments.

I have always been an optimist and believe it is an exciting time to be in advertising and marketing, because the creative supplier network is expanding rapidly and technology is advancing quickly.

The factors contributing to marketers taking back control are:

▸ From an efficiency standpoint, time and budget pressures are on the rise, meaning there is less time to produce assets and an expectation to produce more deliverables with the same or smaller budget.

▸ The traditional production models are outdated, and the market is ripe for fresh ideas and new approaches.

▸ The art of production is complicated by the many people involved.

▸ Advertisers need or want more transparency and control over their content.

▸ Advertisers are working with agencies on a project-by-project basis, thereby diminishing the predictability and profitability of the traditional creative agency model, putting pressure on the sustainability of the long-term relationships between agency and marketing organizations.

‣ In order to become effective at content at scale, we need to push the barriers, break down the silos, and bring together media, creative, production, data, and technology, so that brands can be on demand for their customers and can react quickly to changes in the marketplace.

"There are an unprecedented number of assets produced with little or no oversight. Many people within an organization are responsible for producing content, however, no one owns the enterprise view of content."

—*David Parker, Vice President Digital & Solutions Design, Phillip Morris International*

‣ Procurement professionals focusing on cost reductions will instead have to look for value beyond savings to positively influence the creative-production space. This means cost-cutting measures are second to investing in working smarter and more effectively with great partners.

‣ Advertisers are also seeking transparency into their business, their costs, and the companies doing the work.

‣ Some clients are centralizing the operations of some of the work their agencies traditionally handled, like talent payroll and business affairs.

So, What Do We Do About It?

An overarching content strategy, and more specifically, a creative-production strategy is key in today's modern marketing world, where content is most important, and the oversight of content being produced is centralized and coordinated.

Production is often assigned in an agency scope of work on a project-by-project basis. However, it is more effective and efficient for the marketer to have a bird's-eye view of all the creative needed and to coordinate a more effective approach to the execution for optimal return on investment.

The basics of a content-production strategy begin with:

- **Planning.** Having production conversations up front and early in the planning process

- **Deliverables.** Identifying specific deliverable needs and usage-rights strategy

- **Coordination.** Assembling and coordinating all stakeholders to align on the strategy and approach to production

- **Governance.** Developing ideal framework/guidelines and governance to support a healthy creative and production ecosystem

- **Partners.** Identifying and defining the partnerships with the appropriate companies to do the work

▸ A framework for a content-production strategy might look like this:

Brand Strategy and idea generation	**Where do you get your creative ideas? How do you determine what to produce internally versus externally?**
Creative production and location Strategy	**Defining the approach to producing various types of content**
Partnership management	**Preferred vendors and assignments: Who does what, and what should you be paying for it?**
Production infrastructure/operations	**Assets stored, appropriate insurance, distribution, archives, usage-rights strategy, and tracking, etc.**
Buying Production	**Guidelines for streamlining process, governance, competitive bidding, rate negotiations, and data collection**

There are a number of ways to structure a content-production strategy. The key is to build a flexible framework to support the creative options required and the ability to tap into the right kinds of companies to produce your work. There should be freedom within your framework to support the creative process and give you choices.

Pro Tip:

The ecosystem for content creation is more complicated than ever (containing both creative and non-creative suppliers). What used to be managed by individual agencies is best centralized and coordinated by the marketing organization to effectively address the opportunities and mitigate risks.

Innovation and the Modern Production Environment

Until recently, marketers relied solely on their Agency of Record (AOR) to develop ideas, navigate, and manage their landscape of creative-production suppliers. Today, there are multiple paths a brand can take to produce content. For example, they can produce through an agency or directly with the production house. They can utilize the talents of a high-end, highly specialized director or photographer who works in an *a la carte* manner with specialists chosen specifically for the project, or the project might go to a more efficient company, like a content engine, that produces everything (end-to-end).

Most marketers' goals are to make their budgets work harder and stretch further, recognizing the need to have all of the following:

▸ quality content

▸ brand consistency

▸ streamlined execution

▸ optimized resources

▸ cost management

▸ enhanced tracking

▸ transparency into spend

▸ reporting and data

Notes

Notes

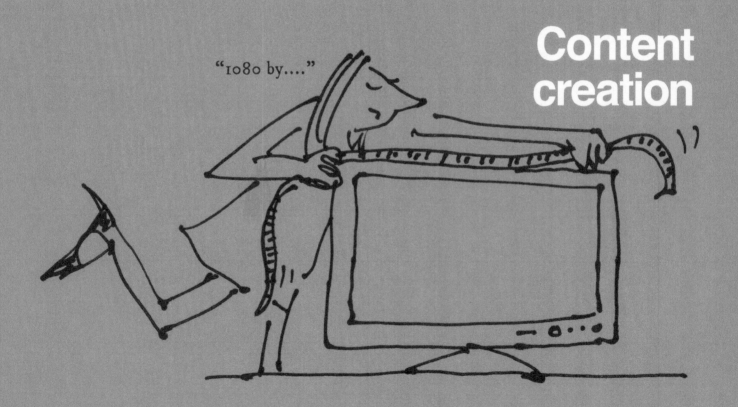

"1080 by…."

Content creation

CONTENT-CREATION PRODUCTION PROCESS

No matter what type of content, or where in the world it is being produced, the process is broken down into three distinct phases: planning, production, and delivery. Within production, the process can be further broken down into Bidding, Pre-Production, Shoot, and Post-Production.

Content Production Process — Snapshot

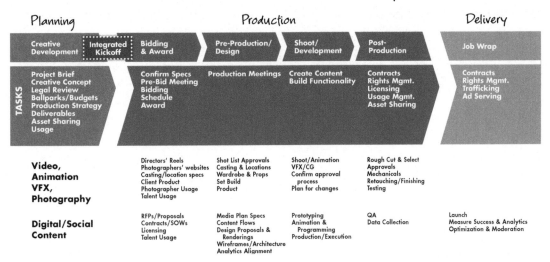

This is a collaborative process, involving many stakeholders, creative, and production partners who come in and out during the different phases of the production. It is important to revisit the project goals often to ensure success, manage expectations, and meet deliverable needs.

11

The Key Production Meetings are:

▸ The Pre-Bid Meeting

▸ The Award Meeting

▸ The Pre-Production Meetings

▸ The Wrap/Reconciliation Meeting (nice to have)

The thousands of variables and nuances within any given creative endeavor all relate to the type of creative needed, the budget, and the timeline. For the most successful outcome, planning and preparation are critical.

The first phase of the production process is **Planning**.

Notes

"Anyone checked the windspeed today?"

Planning

PLANNING
Planning for All Media

The goal of this phase is to get a bird's-eye view of all the activity and deliverable needs on the horizon. We are assuming that you may not have all the information but have enough to begin discussions; this section will detail the planning process as it relates to a specific campaign production, core story, or experience. Before getting started, you, the Marketer, must articulate what type of content will be needed, based on your media plan and brand strategy. Once you have a solid grasp on the content needed, the budget, and the timeline, you can decide how best to approach the production.

Several vital tasks must occur during the planning stage: Briefing, Budgeting, Creative Development, and Scheduling.

The Project Brief

The project brief is at the core of the planning process. This critical document serves to address a common pitfall in the industry: a lack of communication and alignment among teams, stakeholders, partners, and contributors.

There is a tendency for the various creative and production companies to work in silos, independent from one another. Also known as the *integrated brief*, the project brief helps establish alignment from the outset by embracing a coordinated approach across all stakeholders involved, while considering all assets and media channels to be included.

> ## Pro Tip:
>
> **The more thorough and detailed the integrated project brief, the higher the likelihood of overall success.**

Your brief should outline in detail what will be achieved throughout the lifespan of the project, by whom, when, and at what cost. It is the first time all the elements are put in writing, which helps to ensure everyone is aligned *before* the creative team starts the creative process.

> ## Pro Tip:
>
> **"There's a commonly held view that creatives like 'open' briefs—blue-sky briefs—to allow them as much freedom as possible. It's not true. Creatives need a target to aim at. Creatives like briefs to be as buttoned-up as possible." (David Dye)**

Elements of the Integrated Project Brief:

The project brief will have consequences on production, so we recommend that it include these eight key items:

1. **Stakeholders & Partners:**
 Who are the internal stakeholders and external partners who will have impact on the approval process? Who needs to be involved to make the project a success? This can include, but is not limited to, technical/hosting partners, celebrities/

sponsorship entities, sweepstakes partners, *et al.* It is essential to align expectations and involvement of all stakeholders and partners.

2. Success Criteria

How will you measure the success of the campaign? These should be tied to marketing goals and expectations of the project.

3. Budgetary Expectations

What is the budget for this project? It is important to set expectations for the budget. Your creative partners should use the budget information in defining the approach to execute their ideas.

4. Timing Requirements

What is the in-market date (or dates) for each deliverable?

5. Leadership

Who is leading? Who is accountable for each stage of the process, and who is the point person? In other words: who's the decision-maker? It's highly likely there will be more than one decision-maker identified and ultimately held accountable for the deliverables, changes to scope, and approvals of costs. Identifying an Integrated "Team Lead" will provide continuity across asset production and create efficiencies in overall project management through streamlined communications and clear accountability.

6. Legal Mandatories

What specific legal requirements are needed on creative copy, product usage, product benefits, etc. before producing? Are there any country- or industry-specific regulations that need to be considered, such as over-consumption regulations that

stipulate how eating and drinking can be portrayed, age restrictions, advertising for children, etc.? We've seen many ads get trashed after a lot of money had been invested due to legal issues not being addressed beforehand.

7. Deliverables Per Medium

What are the precise deliverables for each medium? When you know what you need going into a project, you will be better equipped to bid appropriately for all deliverables; plan the approach and think through how the message will be supported on all platforms.

8. Usage-Rights Strategy

Do you have a strategy for music, actors, models, illustrations, photographers, fonts, etc.? Each strategy will vary, based on markets and the type of content created. Some assets may be more evergreen and global in nature; others may be local or have a short in-market use. Most marketers, or their agencies, buy more usage than they need, resulting in overpayment, or they under-buy the usage rights, thinking they'll never need to use them. It is important to set the usage-rights strategy prior to beginning negotiations and to negotiate options upfront to renew rights or add options for usage needs that could become necessary for at least the first and second years. For more information on usage rights, see Centralizing Usage Rights Management on page 111.

9. Social Responsibility:

Has your brand set goals to promote diversity, equity, and inclusion both in front of and behind the camera? What about commitments to reduce carbon emissions, including in advertising and production? If so, share these expectations in your brief. More on these important topics on page 121.

Budgeting

Low Cost vs. Higher Investment

Setting a realistic budget is essential to the success of the project and will influence the production approach, type, and level of vendors chosen. For example, you may choose not to engage a traditional production company to produce original social content. It may be better to use a lower-cost social company or client in-house studio, if you have the capabilities.

For setting and adjusting budgets, here are a few different starting points.

▸ It can be a best practice to start off by referring to last year's budget and insights to inform budget planning, assuming a similar approach is required for the current year. Be mindful to adjust for market changes and inflation.

▸ When determining a budget range, consider:

 · The type of creative and the complexity; the brand expectations of the production value

 · The number and type of deliverables (whether you need to capture assets for digital, social, print, etc.), and usage

 · The importance of the campaign in the overall marketing mix. What is the intended distribution? Is it social-media content, which is typically lower cost, or reusable content with a longer shelf life?

▸ Communicate the project budget (or a range) to your creative team prior to creative development, so that they develop concepts to match the budget.

▸ Revisit the budget once the creative is selected, and verify that the concept can be executed within the previously communicated budget. Ensure alignment of parameters regarding what the *all-in* budget is, meaning what is and is not included in that budget, such as talent usage, licensed music, print, etc.

▸ Allocate budget specifically for versioning and reuse. For example, could other regions or PR/ecommerce agencies use this asset?

▸ Hold back 10–20% as contingency (if possible) to accommodate changes and cost overages that could occur.

Complexity in production can influence the time spent on a project and the budget. For example, some creative ideas may include complexities such as: celebrities, licensed music, visual effects, computer-generated imagery (CGI), special props or elaborate set construction, and multiple stakeholders needing to weigh in on approvals.

Creative Alignment

Once the creative team has completed its internal creative process, they will present you with concepts based on the brief you provided. Depending on your deliverables, these could be in the form of concept boards, scripts, storyboards, animatics/pre-visualizations, print layouts, etc.

It is important to ensure that all stakeholders and partners are aligned on previously agreed goals and steps are moving forward.

Key Production Considerations to Discuss During Creative Alignment

1. Campaign Elements

 Is this a fully integrated campaign (i.e., does it include producing assets for a core story and all media), or is this a single execution for one platform, such as a TV commercial? Do any of the assets already exist? Reusing existing assets should be considered before every project is scoped and the specifications are defined for the production companies.

2. Budget

 Is the concept(s) on budget? Ballpark estimates should be provided by the producing agency for each concept, including an explanation for why the creative concept may be over budget. Honest conversations about budget and expectations are key to getting what you need and want out of any production.

3. Schedule

 When finalizing alignment of the creative, you should ask whether the concept can be delivered by the in-market date. There may be production elements that could impact the timeline, such as building a certain prop or set, availability of a celebrity or professional athlete, required approvals from third parties (celebrities, sports organizations, television-network approvals, legal approvals, etc.).

4. Fit For Purpose

 Does the creative match the distribution channel? In other words, is the juice worth the squeeze? For example, are you creating a high-budget, epic video that will be used for only a limited duration on a social platform?

5. Legal

Are there any elements in the creative that will require internal or external legal approvals or clearances? For example, before bidding the job, the agency producer should confirm that all legal approvals of the scripts and storyboards are in place and identify any items that will require a legal affidavit on-set to support a claim in the copy or product demo.

Scheduling

A traditional TV ad takes an average of 8–12 weeks from creative approval to final asset, yet timelines are often compressed, due to a variety of factors. Anything less than 10 weeks should be considered unusual. Every project is different, and the schedule will be impacted by many elements. Anything less than two weeks of preparation for a production would create urgencies and inefficiencies.

"Just-in-time delivery"—getting assets produced when needed—depends on alignment and availability of all stakeholders. Often, the production schedule is driven by how much time you have versus how much time it should take.

If there is a tight deadline and all the team's energy and focus is in "get it done mode," we've seen marketers and their creative production partners turn around a video production in two days. This is, of course, an exception to the rule and should not be expected as a healthy, productive schedule.

The appropriate schedule for a video production that involves casting, many locations, and many stakeholders is 10 weeks, from creative approval to in-market.

Overview
Creative & Production Process (TV)
Production Total: 7- 10 Weeks

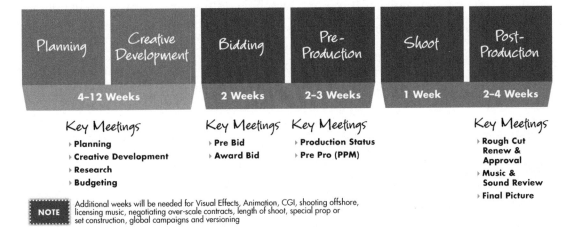

Planning	Creative Development	Bidding	Pre-Production	Shoot	Post-Production
4–12 Weeks		2 Weeks	2–3 Weeks	1 Week	2–4 Weeks

Key Meetings
▸ Planning
▸ Creative Development
▸ Research
▸ Budgeting

Key Meetings
▸ Pre Bid
▸ Award Bid

Key Meetings
▸ Production Status
▸ Pre Pro (PPM)

Key Meetings
▸ Rough Cut Renew & Approval
▸ Music & Sound Review
▸ Final Picture

NOTE Additional weeks will be needed for Visual Effects, Animation, CGI, shooting offshore, licensing music, negotiating over-scale contracts, length of shoot, special prop or set construction, global campaigns and versioning

Real-Life Story:

A quick-service restaurant brand required a series of disparate food shots to be edited into several spots. The marketer's initial request was made Wednesday for a weekend shoot, a request that seemed impossible to meet. It was able to be accomplished because:

▸ The director had worked with the client five times in the past year, so he knew the product, had the trust of the marketer and their creative agency, and was available.

▸ The production company and marketer had a good understanding of budget expectations, based on the previous work.

▸ The shots were simple tabletop shots on stage: No locations to scout, no complicated sets to build, no props to buy, and no casting.

Even though it is possible to rush production, there will likely be challenges if you have too little time in your schedule, such as:

1. Less time for stakeholder alignment, which could impact last-minute changes to scope and drive incremental costs

2. Less time to negotiate, meaning there might not be time to competitively bid or negotiate in your favor

3. Higher margin of error, leading to more risks in the production because the team doesn't have time to think things through properly

4. Supplier overtime and weekend work that can significantly drive costs up

5. Availability of preferred companies or directors to produce the content within your schedule

6. Fewer opportunities to **bundle and integrate** (see next page for more details on the benefits of bundling and integrating multiple needs during a production)

Keep in mind that more time will be needed in your schedule for productions that include things like:

1. Research and testing

2. Visual effects, animation, computer-generated imagery (CGI), digital walls (LED productions)

3. Specific location requirements, such as shooting in a different country, or shooting in a tourist-attraction or popular event location

4. Negotiating celebrity contracts and licensing music

5. Specialty casting, special prop design and build, or set construction

6. Global campaigns that require a lot of coordination, approvals, and versioning

7. Bundling and integrating across campaigns

8. More than three changes in post-production

Any one of these elements, or combination thereof, can add weeks or months to your schedule. You may have to forfeit those that will impact your delivery date. As a best practice, we recommend that the entire team (marketers, agencies, consultants) review these production factors together, agree on the priorities, and understand the impact on the schedule prior to the production bidding process.

Bundled and Integrated Productions

Always be on the lookout for opportunities to bundle and/or integrate your production to make the most out of your investment. Bundling and integrating can yield efficiencies or savings of 20–30% by sharing some of the services, like casting, locations, and crew resources.

Bundling is defined as producing at least two *original* videos (unique concept or script) during a single production for the same media channel/platform. For example, bidding two or more TV commercials to be shot at the same time.

Real-Life Story:

Here's an example of a bundled production from my time at Unilever. I oversaw production for all the television ads across 40 brands. This gave me a bird's-eye view of everything we had in production, across seven creative agencies. J. Walter Thompson (JWT) in New York was the managing agency for a toothpaste brand and for a laundry detergent. These brands had two separate marketing groups at Unilever, and, at the agency, they each had their own account teams, creative teams, and production staff. Both teams were bidding to shoot their TV ads around the same time on location in a house in Westchester, New York.

Because I was tracking all the production activity, I was able to spot the overlap between the two brands bidding the same production company, with the same director, shooting a week apart. I suggested that we bundle the shoots together into the same week. The director would shoot the laundry commercial in the yard and laundry room, and he would shoot the toothpaste commercial in the bathroom, combining the casting calls, prep days, location scouting, and travel costs. This had never been done before, so I explained the situation to the Chief Marketing Officer. I shared the cost-saving potential of 35%, and finally, I articulated the opportunity to be more efficient with the agency and production-company resources. He fully supported the idea of bundling the shoot.

The director agreed to do it as well, as it seemed logical and helped him to maximize his upcoming shoot schedule, by allowing him to take on more projects in the following weeks. Ultimately, we agreed the agency would keep two producers assigned to the project, so that each producer could steward the post-production process, work with different editors, and support their separate brand and agency teams. The production companies saved on casting, location scouts, and location costs. We saved 35% on a two-day shoot.

At APR, we define Integrated Production as producing a variety of assets during a single production for use across multiple channels, such as broadcast, print, digital, and/or social media. Sometimes, these are called "Super Shoots," "Umbrella Shoots," or "Master Shoots" and are expected to deliver cost and time efficiencies in the production process versus producing each asset type in separate scopes.

Both bundling and integrating productions require coordination across multiple stakeholders, including creative teams, film directors, photographers, behind-the-scenes crew, etc. For this coordination to be successful, it will require extra planning and clear communication among all stakeholders and creative partners to gain alignment and prioritization, especially on-set during the shoot day. It will be worth the coordinated effort and is recommended for optimal efficiencies. After the shoot, additional coordination will be necessary to deliver appropriate elements for the post-production phase of each asset type to the appropriate creative agencies.

Pro Tip:

For those marketers who are faced with shrinking budgets and timelines, it is common to see marketers producing a large amount of content in one shoot. The challenge is to define clear deliverables, script variations, and the media plan prior to bidding. Without these three things, the budget efficiencies can go out the window, and costs will likely be higher than necessary.

An alternative and cost-effective approach to producing your moving-image assets for Out of Home (OOH) and social assets versus piggy-backing onto the live-action shoot of a TV Ad, for example, is to produce the motion footage on a photography set. Due to the advancements in cameras, photographer-led shoots often include some

action or motion capture. If the criteria are suitable (resolution, creative execution, photographer capability, etc.), it's worth considering as a solution for digital, social, and OOH assets.

During the upfront, early stages of your production, it is important for you to pay attention and contribute in a timely manner. Here is a checklist summarizing this chapter for your convenience.

NEED TO KNOW: PLANNING CHECKLIST

- ❑ **Identify all stakeholders** upfront who will contribute to the decision-making or who need to be informed about what's going on.

- ❑ Create **an integrated brief** that takes into account all deliverable types, when they're needed, the media plan, and your usage-rights strategy.

- ❑ Even though you may have set your budget during annual planning, **re-evaluate the budget at the project level.**

- ❑ **Hold back 10–20%** of the budget (if possible) to accommodate changes, creative opportunities, and cost overages that could occur.

- ❑ **Allow enough time to produce** within industry standard of ten weeks, or understand and be accountable for the trade-offs of an expedited schedule.

- ❑ Consider **repurposing existing assets**. A good rule of thumb, and sustainable approach, is: Adopt, Adapt, Create. In other words, try to use existing materials first, adapt those materials to suit your creative objectives, as needed, or, if nothing exists in your content library, create new material.

- ❑ Identify which assets can be produced together to create efficiencies (**bundling or integrating**).

Notes

Notes

PRODUCTION
Buying Production and the Bidding Process

*O*nce the creative concept or idea is approved, all stakeholders are identified, the budget is shared, and the timeline or schedule is understood, it is time to figure out who is going to produce your content. The buying process is influenced by any preferred partner deals in place, the pre-defined bidding process, or managed through an RFP process. This is typically led by an external creative agency or other marketing resource on your behalf. There are companies who choose to manage the production buying process for themselves; either way, here's what you need to know.

There are six steps to the bidding process:

Bidding/RFP Process

#1 The Pre-Bid Meeting

Bidding/RFP Process

Step 1 in the bidding process is the Pre-Bid Meeting. The Pre-Bid Meeting is **the** most important meeting in the entire production process.

The Pre-Bid Meeting[1] sets the stage for the success of the production and articulates the project scope to potential bidders. This meeting should occur upon creative approval and ***prior*** to the discussions with production companies. Attendees should include the marketer managing the production, other marketer stakeholder(s), personnel managing the bidding/pitch process, including the producer/art buyer, account reps, creative team, business manager, and production consultant. Legal and creative issues should be resolved prior to this meeting. Bidding too soon can result in a poorly defined scope, leading to re-bidding, adding more time to the schedule, the potential for unforeseen overages, and suppliers dropping out of the pitch due to schedule conflicts. So, you don't want to start bidding before you're ready.

Details to confirm (or at least discuss) at this meeting include, but are not limited to:

a. Content (Storyboards, approvals, creative vision, including integrated-content needs) and all known deliverables

b. Rationale for supplier selection (Review sample work of potential directors or photographers)

c. Rationale for single-bidding a supplier, if applicable (rarely recommended; see below for explanation)

d. Talent (review preliminary casting specs/brief, number and type of talent)

e. Shoot location/country (general discussion about the locations to be bid;

f. Production budget (inclusive of all costs) and a detailed list of costs *not* included in the production budget

1 See sample Pre-Bid Meeting agenda in the Appendix.

g. Production calendar (with client approval dates identified)

h. Music (discuss music direction for bidding purposes)

i. Asset usage (identify which assets are licensed, under union agreements, or owned by the company, often referred to as "work for hire")

j. Product availability and logistics

k. Legal complications, status of legal approvals, or issues

l. Media specifications and correct formats (e.g., screen size/aspect ratios and specific platform guidelines)

m. DE&I and sustainability expectations, defined guidelines and goals shared, with budgets related to fulfilling commitments

n. Health and safety requirements

Steps 2–5 of the bidding-and-award process happen behind the scenes, led by the designated responsible party. While you may not be directly involved, it's important to have a high-level awareness of what happens during all these phases.

Bidding/RFP Process

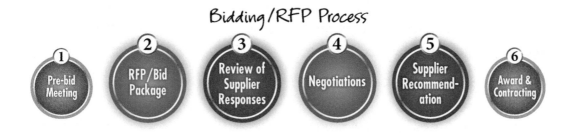

#2 **Bid Package/RFP (Request for Proposal)**: The bid package—referred to as a Production Brief in APAC or Production & Insurance Briefing Specification (PIBS) in the UK and EMEA—is sent to each vendor. Bid package/specifications (specs) include creative concepts and details such as deliverables, bid guidelines, insurance responsibilities, budget, and timings.[2] Each bidder will receive the same package from which to develop and submit a production approach and budget.

#3 **Company/Supplier Response**. The response from each company includes a detailed bid, schedule, and treatment. **A treatment** is the director's or photographer's visual and written representation of how the concept will be brought to life. The treatment details the specific approach to the production and is the basis for the project costs. If there are multiple companies bidding, such as live-action, tabletop, and volume-stage approaches, you should request to receive treatments from each company, as each will have their own way to illustrate their approach, which will affect their costs.

#4 & 5 **Negotiations and Supplier Recommendation**. Negotiations occur between the stakeholders or their representatives, production companies, and production experts or consultants, if involved. Alignment on the preferred companies should happen before the final bid negotiation. The responsible party then outlines all costs in an estimate to let the marketer know exactly what they are buying and—equally important—what they are *not* buying; exclusions are as important as inclusions. Transparency into who is bidding is important. Agency in-house should not be bidding against independent production companies; this is a conflict of interest and could carry legal ramifications.

2 In APAC, standardized bidding templates are not common but can be requested or provided for the sake of transparency.

Awarding the Job

Bidding/RFP Process

 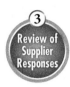

#6 **Award and Contracting:** The last step of the bidding process is to award the project to the company or companies who will do the work. Once the production partners have been selected and their bids have been finalized, the marketing and creative agency sign the production estimate. At this time, the commitment is made, and the train has left the station. The signature is a contractual agreement that triggers a lot of activity and can be difficult to change. All companies will receive formal notification, in the form of a Purchase Order (PO), contract, or Statement of Work (SOW) and submit initial invoices equal to a significant percentage of their estimate, often 50-75%.

Before signing off on the costs and awarding the project, it is a best practice to have an Award Meeting, to review all the details and confirm commitments. Depending on the nature and complexity of the production, this could be a conference call or a more-involved meeting with supporting documentation to ensure the team is aligned before moving forward.[3]

When you sign an estimate, you are agreeing to three things:

1. **The Timing:** Agreement to the proposed schedule, including shoot dates, production and post-production approval dates, delivery dates, and payment terms.

3 See sample Award Meeting agenda in Appendix

2. **The Approach**: Agreement to the creative approach presented by the chosen companies.

3. **The Costs:** Agreement to the budget. Once the estimate is signed, the suppliers will start work; any changes, postponements, or cancellations will have cost implications. This is when you should set the expectation to reconcile final costs at the end of the project.

Payment Terms. Payment Terms can be a real stumbling block for production and have been an ongoing issue for more than 20 years. Typically, the payment terms are separated into two, often three, payments upon award, or:

▸ upon the first shoot day

▸ upon receiving the footage

▸ and upon financial reconciliation of cost-plus and/or other costs requiring documented proof

The marketer pays their agency, who pays the production companies, editors, visual-effects houses, and so on.

It is worth noting that, in some cases, the marketer/client pays the production companies directly, and exceptions are made to standard client payment terms so that the production can be funded. In either case, whether the client pays the agency to pay the production company or the client pays the production company directly, provisions need to be made prior to the Award Meeting to make the funds available quickly.

Once a job awards, a production company sends an invoice to the agency (or client, if working directly), typically for 50–75% payment, depending on client guidelines and global

region. At that same moment, a production company begins spending that first payment, long before it is received, to make a tight client schedule work. It traditionally takes 5–10 days (at a minimum) for a supplier to receive that first payment, and then it takes a bank 1–2 days to clear that electronic payment and make the funds available. In essence, these small businesses are expected to float or fund the immediate expenditures without having received payment—and we are talking dollar amounts well into the six and seven figures. This float is an unrealistic expectation and also impractical for the many small businesses who support the marketing-production industry.

As margins shrink, floating or bankrolling the start of a production will become less viable and less popular. And, given client/agency loyalty is waning and agency/supplier relationships are changing, more and more suppliers will be forcing the agency's or client's hand on timely contractual payment obligations.

To address payment terms appropriately and fairly, it is recommended that:

▸ The payment terms are called out in the bidding process, often within bid-specifications documents (RFPs), and the contractual obligations reiterated at the Award Meeting.

▸ The proper contact accountable for transferring funds should be identified and included in the Pre-Bid Meeting, so they are aware of the award date.

▸ The allotted dollar amount for production should be identified, transferred/deposited from client to agency, in preparation for first payments due.

Agency producers or business managers should be included in Pre-Bid Meetings to ensure they can trigger the money transfers from brand to agency at the right time and in preparation for receipt of production supplier invoices.

The agency should communicate to the client that, should payment not be available upon award date, client risks a stop-work situation, which, in the end, can delay the production and cost far more.

It is critical to address payment terms more broadly, define exceptions, and develop a process for funds transfer that all parties can work with.

Also at the time of award, it is important to review and understand the policies for billing, postponement, cancellation, and weather days.

Real-Life Story:

Early in the month of May, a marketer awarded a five-day shoot in Vancouver, to occur in late May. A few days passed, and the marketer alerted the agency that additional senior marketers intended to be on-set and would have to move the shoot schedule to mid-June. The marketer was surprised to learn that this request would trigger $100,000 in additional costs. The marketer protested, noting that the job had "just been awarded" and that it was simply a minor postponement. The marketer seemed unaware of what the award of a job sets in motion: the production and post-production houses, the crew, and other suppliers had booked the time for the marketer and likely turned down other work. In the end, they decided not to spend the $100k and stuck to their original schedule.

Competitive vs. Single Bidding

It's important to understand that selecting suppliers (director, photographer, animator, editors, and/or music houses, etc.) is part of the creative process. Depending on the project, there may be one supplier who is going to do the whole project, or separate suppliers handling parts of it.

To competitively or single bid...that is the question

It is recommended that you competitively bid for all services, as it has several advantages:

1. It allows you to leverage bids for more-impactful cost negotiations and can result in significant savings

2. It yields more creative options from which to choose

3. It ensures a backup plan, should your recommended supplier become unavailable

However, there are times when single bidding is appropriate. It's important to be familiar with your production guidelines and evaluate each project accordingly, to determine if it should be competitively-bid or single-bid.

Single-Bid Advantages

1. Provides the opportunity to negotiate for preferred rates for repeat business or for the advantage of being single-bid

2. Brings efficiencies on bidding, preparation, and pre-production activities on continuing campaigns or with a specific executional style to be replicated by the same director or photographer

3. Expedites the bidding phase during a super-tight schedule

There are also potential drawbacks with a single-bid approach. For example, a company who is being single-bid on a project will have less incentive to negotiate if they know they are the only one in the mix. Single-bidding can leave the marketer more vulnerable,

especially if there is no backup plan, should the company being single-bid back out of the project. This could also add two to three weeks to the production.

Choosing Suppliers

The creative or production teams may review many directors' reels or photographers' portfolios, music houses, and other suppliers before deciding on a shortlist for bidding and to share with you. So, how do you decide who to bid from their shortlist?

1. *Expertise:*

 Most directors or photographers specialize in a specific genre or production style. Your project may require any one of the following or a combination thereof. Some directors might specialize in comedy, visual effects (VFX), tabletop, or product shoots. Likewise, in photography, there are specialists in product, lifestyle, portraits, automotive, beauty, etc. This graphic depicts the variety of styles and genres offered by directors and photographers:

Narrative	Visual, Dialogue, Docu-Style, Dramatic, Emotional
Comedy	Broad, Real, Quirky, Subtle, Dark, Visual, Dialogue, Parody
People	Celebrity, Babies, Kids, Lifestyle, Testimonial, Real People
Fashion & Beauty	Cosmetics, Hair, Apparel, Studio, Location, Fantasy
Sports	Mainstream, Extreme, Celebrity Athlete, Everyday, Rigs
Visual	Action, Landscape, Vignette, Cinematic, Aerial, Underwater
Tabletop	Food, Liquids, Packaging, Macro
Cars	Studio, Rigs, Running Footage, High-Speed, Rough & Tough
Visual FX	CGI, Integrated Graphics, Matte, Motion Control
Animation	2D, 3D, Stop Motion, Cel, Claymation
Physical FX	Fire, Water, Stunts, Multi-Camera, Weather, Aerial
Animals	Domestic, Wild, Animatronic, As Characters

2. **Past Experience/Relationship:**
In some cases, the creative team has past experience working with this supplier, so they know they can be trusted to deliver on the specific project needs.

3. **Understanding of Concept/Shared Vision:**
The director or photographer shares the same vision as the creative team of how to bring the concept to life. The marketer also needs to be on-board with this vision. There are plenty of occasions where there is misalignment, leaving the marketer feeling blindsided.

4. **Competitive Pricing:**
Perhaps this supplier has the ability to work within your budget range.

5. **Schedule:**
Sometimes, it's as simple as if these companies/directors/photographers are available for your schedule.

Reviewing Directors' Reels or Photographers' Portfolios

One of the key agenda items on the Pre-Bid Meeting is discussing the type of directors or photographers that the agency is considering. Many times, this will include reviewing directors' reels, photographers' portfolios, and other materials. If no reels are presented at the Pre-Bid Meeting, the creative team, or whoever is running the process, should send them out shortly after this meeting.

A reel or portfolio is a promotional tool that artists use to show examples of their previous work.

Creative teams generally present directors or photographers to bid on your project based on their technical and creative skills, experience, and ability to deliver the ad effectively. You are not making a final choice at this point, but rather aligning with the creative team on the suppliers' abilities to deliver your concept as intended (such as visual tone, style, or performance). You should feel comfortable that any of these suppliers can meet the needs and expectations of your project. The final decision will be made later, after you have had an opportunity to review their creative treatments.

Casting Brief Specifications (aka Casting Specs)

What information do you want your Casting Director to have prior to conducting a talent search? A casting brief is a detailed written description that communicates your idea and brand message along with the list of roles to be filled. In a perfect world, a casting brief (also known as casting specs) will be presented to the brand team at, or right after, the Pre-Bid Meeting. The casting spec may be revised once the Director's treatment is reviewed and approved. NOTE: The casting brief should be finalized in time for the Award Meeting, because, immediately upon award, the production team sends it to the casting director, and casting begins.

Casting Specs Criteria

1. *Characters/Roles and how many:* Who are the characters that will bring your story to life? Are you using actors, real people, employees? Is it a cast of one or one hundred?

2. *Classification:* How many primary speaking or non-speaking roles do you expect? How many extras will appear in the background?

3. **Ages or age ranges:** How old is each character? Each role should have an age range assigned to it.

4. **Gender and Ethnicity:** Are you incorporating diversity across casting for lead and background actors?

5. **Characteristics/Look:** What do they look like, such as masculine, approachable, girl or boy next door, model-like, nerdy, etc.?

6. **Speaking roles:** Do they need to speak any specific languages and/or dialects?

7. **Specialty skills:** Do they need special skills, such as walking and talking, singing, athletics, juggling, swimming, etc.?

8. **Usage:** What is the anticipated use, territory, and term length of the content? This is essential for negotiating.

 a. Example use: Internet, social media, industrial, regional TV

 b. Example territory: Worldwide, US and its territories, Mexico only, LATAM, etc.

 c. Example term: Six months, one year, three years, perpetuity

9. **Category Exclusivity:** Do you need category exclusivity on the actors to prevent them from appearing in a competitor's advertising campaign at the same time? If so, what are your conflict categories? Microsoft is a good example, because they have to choose exclusivity for either hardware, software, or both.

Location Expectations

A discussion about the location, or a more detailed brief (aka location specs) should occur at the Pre-Bid Meeting and be confirmed at the Award Meeting.

Pro Tip:

Visual references, like photographs, are always useful for location briefs, in order to avoid misunderstandings and gain alignment.

Where is the shoot going to take place? After the project is awarded, the production company will send out a location scout to find appropriate options. The production company returns with photos that meet the location specs for the project and should provide multiple options from which the marketer may choose and approve.

Location Specs Criteria

1. What environment are you shooting in (studio, home, retail space, restaurant, hiking trail)?

2. What is the geography of the space (green meadow, mountain, desert)?

3. What is the style of building or location (modern, classic, upscale)?

4. What type of styling is desired for the location? Some directors or photographers will try to push for "real" or "raw," which can turn out to mean *downcast and gritty* and may or may not be on brand. Again, visual references are important to gauge this level of styling to ensure everyone is on the same page.

5. Are you using a partner facility (franchise or branch location)?

NEED TO KNOW: BIDDING TO AWARD

❑ Attend the Pre-Bid Meeting

❑ Ask the creative team for their vendor criteria (why are they suggesting these potential vendors?)

❑ Ask to see director reels or photographer portfolios prior to bidding (before or at the Pre-Bid Meeting). Request to see more work if necessary, and confirm availability.

❑ Review the treatments of *all* vendors (not just the recommended one) with the creative team and request a POV on their recommendation. Treatments should be provided with adequate time to review before the award.

❑ Ensure that you agree with the recommendation; this is the time for you to raise any questions or concerns you may have before awarding the job.

❑ Sign the estimate *only* if you agree with the creative approach, the schedule, and the costs.

❑ Understand guidelines for billing, postponement or cancellation, and weather day, as they will have cost implications.

❑ Upon award, stakeholders and vendors should align on casting and location specs.

Preparing for Your Production

You've now awarded the job, and the pre-production phase is off and running. Between now and the shoot, there are many decisions and approvals required from you, so regular check-ins and consistent dialogue with the agency and your production expert, if using one, is essential throughout the process.

You and your team will determine the appropriate communication cadence that suits the needs of your project. It is recommended that you review and approve items as they are presented to keep things moving and on schedule. The pre-production phase is iterative, and it is best not to wait until the formal Pre-Production Meeting to make all approvals, as it may be too late to make changes.

The contracted production companies will begin by casting and scouting for locations (based on previously approved brief/specs[4]) and hiring the crew to bring your production to life. You will then be presented with casting selects and location photos.

Casting

Your role in casting selection is to:

- ▸ Review auditions of the on-camera talent so you can see the "special skills" required, such as juggling, horseback riding, even walking and talking.

- ▸ Insist on 2–3 talent choices per role

- ▸ Confirm diversity of cast matches the approved casting brief/specs

4 See page 45 for casting and location details.

> ## Real-Life Story:
>
> Seeing is believing. Once on a shoot, an actor had to walk toward camera and talk at the same time. We did not see him demonstrate this ability at the casting call, so who knew that his arms would sway weirdly while he walked? We had to tighten up the shots and alter the script to make it work.

▸ Confirm the number of extras needed in the background

▸ Discuss media usage, and ask how any talent changes/additions will affect the budget

Location(s)

Your role in location selection is to:

▸ Understand any restrictions or clearances needed for recognizable or popular tourist locations. For example, you may be able to shoot only at night or on the weekends for certain locations, which may have implications for the schedule and the budget.

▸ Make sure you are comfortable with the look-and-feel of the location and how it aligns with your brand. If the production company is planning to build out or "dress" the location, it is a best practice to request detailed styling references (props, colors, design elements, furniture style) *ahead* of the shoot day—and usually at the Pre-Production Meeting.

▸ Understand approvals and coordination if using facilities such as in-store shoot locations, a franchise, or branch locations. These may have an impact on your timing, as approvals can add to your schedule.

Other items on which to align:

▸ Wardrobe and props: You will be shown representative styles and photos.

▸ Product needs: Confirm which products are required (such as real product, signage, competitive product, hero production/color-correct packaging) and who is responsible for securing these items. Request actual props and product be available at the Pre-Production Meeting, so you can see them with your own eyes.

▸ Logistical concerns: Discuss any complicated logistics such as safety requirements, stunts, drones, helicopter shots, choreography, etc.

▸ Budget: Confirm that creative recommendations are in line with the approved budget.

▸ Travel arrangements: Finalize travel arrangements for marketers, employees, celebrity talent, etc.

▸ Schedule: Work out complicated schedule logistics (celebrity, all media needs, co-sponsorships, key stakeholders for approval on set, etc.)

▸ Music direction: Once again, review and update music- and sound-design considerations. Review and discuss music specs/direction. Listen to samples, if available.

▸ Legal issues: Re-confirm that all legal approvals are complete, and discuss any issues that have arisen during the legal-review process.

Pre-Production Meeting (aka Pre-Pro; PPM)

The Pre-Pro Meeting is the meeting held just prior to the shoot to finalize and align all production details. This may be the first time you will meet the director, photographer, line producer, or post/visual effects (VFX) supervisor or director. Ideally, it should be held in person at least two days before the shoot (if possible), in the same city as the shoot. Be sure to include a time buffer in case there are re-directs or changes decided at the Pre-Pro Meeting. Attendees should include the marketer managing the production, any additional marketer stakeholder(s), agency personnel, including producer/art buyer, account reps, and the creative team. Depending on the needs of the project, additional department heads, such as an editor, VFX supervisor, choreographer, and the marketer's production consultant, *et al.* should be in attendance.

The main purpose of the Pre-Production Meeting is for the director and/or photographer to review their shooting board and/or shot lists. A shooting board is the director's plan (or blueprint) for executing the script/storyboard; it contains detailed sketches of all scenes, camera angles, and/or camera moves.

A photographer's shot list breaks out the order and number of shots that will be executed. Keep in mind, a shot list may also be provided by a director.

If this is an integrated production, where you are shooting to get multiple assets for multiple platforms, you will need shooting boards or shot lists for each platform to be aware of alternative framing needs, especially for social and digital assets.

You should also clarify shots where products are featured, and determine if you will want "hero" packs, or is this just a shot where the product is noticed rather than featured?

A hero-pack shot is when the label is mocked up to be camera-ready; it may exclude many of the details contained in an in-store label, and it may need to be waterproof because of the filming technique or other on-set needs.

Don't forget: this is your campaign, and the brand is the final arbiter of all the choices. You should not feel intimidated by all the voices in the room. During the pre-production, don't be afraid to raise your hand and ask the obvious question because someone else may be thinking the same thing, and they will be glad you asked it.

> ### Pro Tip:
>
> **Your main role at a Pre-Pro Meeting is to ensure that brand expectations are clear; prioritize the shot list, identify the shots that are integral to your storytelling, aka "magic moments," and ask questions. Don't be afraid to ask questions.**

The Pre-Pro Meeting is also an opportunity to share and align on business and marketing objectives of the campaign. Oftentimes, the production company doesn't get to hear the business objectives and is simply delivering on the execution. It is a best practice to share your business and marketing objectives with all stakeholders to ensure optimal results and more fruitful partnerships.

There are a number of other details to confirm at the Pre-Pro Meeting, including[5]:

▸ Wardrobe fittings with talent

▸ Production schedule, including daily call times

▸ Weather forecast and potential risks for overages

5 See sample Pre-Pro Meeting agenda in Appendix.

▸ Communication protocol for providing feedback on-set.

· A communication protocol should prepare you to address potential issues that could arise on-set and eliminate confusion and chaos. You are responsible for getting the approved content captured, and without the appropriate protocols, the implications can be frustrating, time-consuming, and expensive.

· Questions to ask and discuss with the agency producer to ensure a well-defined communication protocol[6] on set:
 → Who will be the point person checking in with you and your team directly and regularly during the shoot?
 → What is the approval process for moving on to the next set-up? Who from the marketer side is the decision-maker and will give the appropriate feedback to the point person?

"I'm hungry - could someone find me some Guava fruit?"

6 See more about communication protocol in the Shoot section, page 64.

→ What's the process for overages? You should make it clear not to spend any more money without your approval in advance.

→ What if you don't like the way the actor is reading the line?

→ What if a change in weather impacts the shoot (e.g., rain, wind, snow, smoke from fires, etc.)?

→ When can you take a break and make a phone call? And, is there any impact to cell or Wi-Fi service at the location?

NEED TO KNOW: PRE-PRODUCTION PHASE

❑ This is your campaign, so it's good to take a hands-on, proactive approach to the project. It is important you are heard and get what you need.

❑ As a best practice, you should approve casting and location specs before, or at, the award of the job.

❑ Make sure the creative team presents backup options for each role to be cast (at least 2–3)

❑ Review auditions of the on-camera talent so you can see the "special skills" required

❑ Understand any restrictions or clearances needed for recognizable locations. Has the legal team approved the location? Are there any restrictions with locations?

❑ Consider approving casting and locations prior to the Pre-Pro Meeting (this allows time to hold additional casting sessions if necessary).

❑ Understand and discuss usage. Talent contracts with options should be signed at, or prior to, wardrobe fitting for all video, print, and social shoots.

❑ Ask how any talent changes will impact the budget, such as adding more principal actors to the cast, possible upgrades to the extras on set, etc.

❑ **At the Pre-Pro Meeting**:

→ Ensure a shooting board or shot list is available.

→ Be heard; ensure brand expectations are clear; share the business/marketing strategy at the Pre-Pro Meeting.

→ Ask questions.

→ Prioritize the shot list; identify "magic moments."

→ Discuss communication protocol on set.

Production: At the Shoot

After all the i's have been dotted and t's crossed during pre-pro, it's time for the shoot.

To keep activities organized and on schedule, a call sheet should be distributed by the production company to the crew and agency the night before. Your agency account representative will send the call sheet to the marketing stakeholders attending the shoot (and your production expert, if attending), along with the confirmed call time. The call sheet details who needs to be where and when: the crew, the camera department, the talent. It identifies who is involved with the production and how to contact them.

A separate document—called a timed shot list or "shoot schedule"—should be provided by the production company that details which scenes will be shot that day, and allocated times to complete each scene, including location information, should you be shooting in multiple locations on the same day. This is the road map for the shoot days and is critical for you to have in your possession.

Here's a sample of a production company call sheet:

Production Company

CALL SHEET

DAY 1 OF ?

BREAKFAST:	6:00am		GENERAL CREW CALL:	7:00am			

Client:	Agency:	Locations 1	Location 2
Chromatic Chorus Co. 1234 High St. New York, NY 10019 Tel: 212.123.4567	**Ground Beat Advertising** 1234 Main St. Philadelphia, PA 19101 Tel: 215.123.4567 Fax: 215.123.4567	Jogging Columbus & Jackson Chicago, IL 60605	Grant Park 1109 S Columbus Drive Chicago, IL 60605
Production Co:	**Production Contact Inormation**	**Loc 1 Hospital:**	**Loc 2 Hospital:**
Jazz Giants Inc. 1234 Main St. Los Angeles, CA 90066 Tel: 310.123.4567 Fax 310.123.4567 Directors: Miles Davis + John Coltrane Founder/Executive Producer: Dizzie Gillespie President: Louis Armstrong	Bill Evans: 310.123.4567 Billie Holiday: 561.123.4567 Thelonious Monk: 215.123.4567 Charles Mingus: 312.123.4567	Northwestern Hospital 201 E Huron Street #105 Phone: 312.926.3627	Northwestern Hospital 201 E Huron Street #105 Phone: 312.926.3627
		Sunrise: 6:42 AM	Sunset: 6:23 PM

CREW	NAME	PHONE	ALT.	CALL	WRAP	CLIENT & AGENCY	NAME	PHONE	CALL	WRAP
Director				6:45aLV		Client			7:15aLV	
Line Producer				6:45aLV		Client			7:15aLV	
Prod Supervisor				6:45aLV		Client			7:15aLV	
Asst Prod Super				6:45aLV		Client			7:15aLV	
1st AD				5:45aLV		Client			7:15aLV	
2nd AD				5:45aLV		Agency			6:50aLV	
DP				5:45aLV		Agency			6:50aLV	
1st AC				6:45aLV		Agency			6:50aLV	
2nd AC				6:45aLV		Agency			6:50aLV	
DIT				6:45aLV		TALENT	NAME		CALL	WRAP
Gaffer				6:15aLV		Jogger			6:00aLV	
BB Electric				6:15aLV		Jogger			6:00aLV	
3rd Electric				6:15aLV		Jogger			6:00aLV	
4th Electric				6:15aLV		Jogger			6:00aLV	
Key Grip				6:15aLV		Park Couple			10:00aLV	
BB Grip				6:30aLV		Park Couple			10:00aLV	
3rd Grip				6:30aLV						
4th Grip				6:30aLV						
Art Director				6:30aLV						
Propmaster				6:30aLV						
Prop Assist				6:30aLV		EQUIPMENT	VENDOR	PHONE	FAX	CONTACT CALL
Ward Stylist				5:45aLV		Camera				
Ward Asst.				5:45aLV		Car Rental				
Hair Stylist				5:45aLV		Caterer				
Make-Up Artist				5:45aLV		Grip / Electric				
Make-Up Assistant				5:45aLV		Insurance				
Script Supervisor				7:00aLV		Motorhomes				
VTR				6:30aLV		Payroll				
Location Manager				OC		Prod. Supplies				
Craft Service				6:30aLV		Travel Agent				
PA				5:15aLV		Trucks				
PA				5:15aLV		VTR				
PA				5:15aLV		Walkies				
PA				5:15aLV						
PA				5:15aLV						
Medic				6:30aLV						

PRODUCTION SUMMARY		
1st Shot		
Lunch		
1st Shot PM		
2nd Meal		
Camera Wrap		
Crew Wrap		

First Time on Set? No Sweat!

This section should be viewed as a quick guide for a marketer attending their shoot in person.

First things first. Before you arrive on set, ask these questions of the agency producer:

▸ What should you wear? Comfortable shoes, comfortable clothes. Bring all your medications and things you may need for the day, which may run long. The weather at the call time may not be the same as when you finish. Will you be inside or outside?

▸ What time do you need to be there? Do not be late! Time is money, and everything is methodically coordinated to work within the time frame that you bought.

▸ How will you get to set? Will you be driven? Do you have directions?

▸ Will breakfast be provided, or do you need to come to set "having had" (having already eaten) breakfast?

Once you arrive:

▸ There is always a safety-protocol meeting run by the production company, but it is usually before the brand arrives on set. Do yourself a favor and be there for the safety-protocol meeting, or ask for a safety debrief upon your arrival.

▸ Ask for the day's shot list with estimated shoot times.

▸ Ensure that all wardrobe, hair, and makeup is approved for every cast member before they appear on camera. Once shooting begins, you will not be able to change the wardrobe without significant costs to reshoot scenes already shot in the previous wardrobe.

▸ Approve key props, camera-ready product, logos, labels, etc. Ask to be introduced to the props master, and then walk over to the props table and have a look for yourself!

▸ During filming, you should not go too far away from video village. Should you be needed, the production team needs to know where to find you. Please let the agency or your in-house producer know your whereabouts at all times.

▸ A lot is going on, and there are some dangerous areas on set. It's a good idea not to get buried in your phone. Keep your head up, and stay aware of your surroundings and what is going on.

Production Crew: Who's Who on a Film Set?

On a film set, depending on the size of the production and the budget, the crew might consist of between 10 and 100 people. On larger productions, crew members have specialties, as outlined below. On smaller productions (e.g., social video), crew members are more flexible and may fill multiple roles. In integrated productions, there may be multiple people providing the same function for different deliverables.

Video Production Crew Who's Who

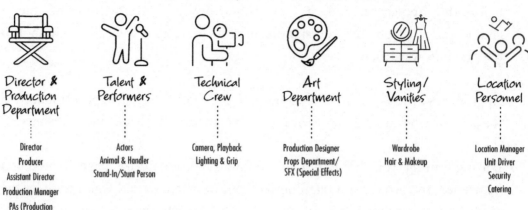

Director & Production Department	Talent & Performers	Technical Crew	Art Department	Styling/ Vanities	Location Personnel
Director	Actors	Camera, Playback	Production Designer	Wardrobe	Location Manager
Producer	Animal & Handler	Lighting & Grip	Props Department/	Hair & Makeup	Unit Driver
Assistant Director	Stand-In/Stunt Person		SFX (Special Effects)		Security
Production Manager					Catering
PAs (Production Assistant) & Runner					

Who's Who on a Photo Shoot

On a photo shoot, the crew is much smaller, but, overall, the personnel and departments are similar. Many photo shoots have social video components, so a small video crew with specific responsibilities may be added to those below.

Photography Crew Who's Who

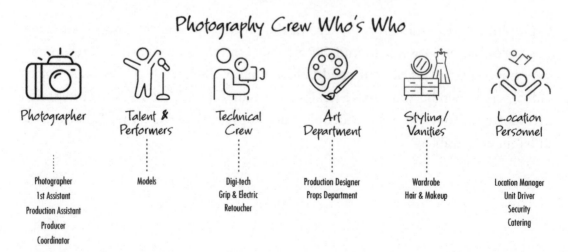

Photographer	Talent & Performers	Technical Crew	Art Department	Styling/ Vanities	Location Personnel
Photographer	Models	Digi-tech	Production Designer	Wardrobe	Location Manager
1st Assistant		Grip & Electric	Props Department	Hair & Makeup	Unit Driver
Production Assistant		Retoucher			Security
Producer					Catering
Coordinator					

Setiquette (On-set Etiquette)

A shoot is expensive, and time is money. Once you're on set, and if all the preparation and best practices have been followed, you should feel comfortable with everything. However, things will still come up that need your attention.

The main role of a marketer on set is to approve the captured video footage or still photography images before moving to the next shot. The protocols for sharing marketer feedback on set with the director, photographer, and/or production team should be defined at the Pre-Production Meeting, and no later than the beginning of the first shoot day, as outlined in the pre-production section (page 49).

On a typical video production, you'll be in a designated area with monitors, known as "video village." Here you will sit with the creative team, watch the monitor, and listen to audio through a headset as the camera is rolling. The size of video village will vary, depending on the type of production, budget, and number of marketers on set. A photo shoot is less formal than a video shoot, and with fewer crew members on set, the feedback from marketer to photographer will be more direct.

On particularly complicated shoots, for example, working with celebrities, children, animals, etc., there may be factors that make the communication protocol more complicated. This should all be considered in establishing the communication protocol on set.

An example of such a protocol may be that you (the client) communicate with the agency, who communicates with the line producer, who communicates with the director, who communicates with the actors and the crew. Never would you give direction to the actors or crew. This is the director's job.

Communication Protocol On Set

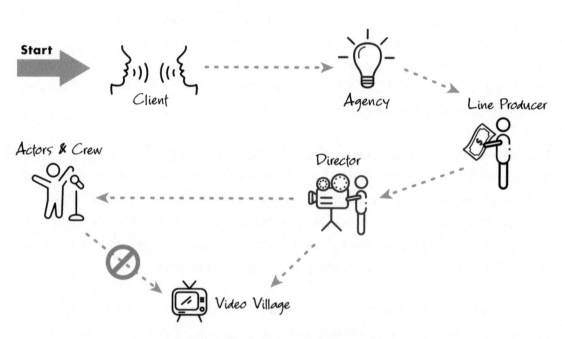

See Details to Confirm at the Pre-Pro Meeting, page 53.

Once a shot has been captured, it's appropriate for the director and/or the line producer to communicate with you to ensure that you are satisfied with the scene.

Occasionally, the production company or agency will give the green light on the marketer's behalf, but this is a **red flag** moment to look out for. If the marketer doesn't approve the shot, accountability and process go out the window (not to mention time and money).

The last thing anyone wants is for the crew to start setting up for the next shot while the marketer was busy taking a phone call or otherwise not paying attention. It is very costly to re-shoot a scene and could be detrimental to the production.

> ## Pro Tip:
>
> **The marketer should set the expectation that they want to be informed before anyone moves forward to the next scene.**

Other marketer responsibilities on set include checking the product, building relationships with the team, and allowing the experts to do their jobs. It is helpful to the creative process to define the guardrails that ensure the marketer needs are met, yet still allow room for creative flexibility.

> ## Pro-Tip:
>
> **Remember why you're there. Shoot the board and watch out for brand-related or legal issues.**

Set Safety

Set safety cannot ever be assumed or taken for granted. While certain props like firearms aren't typically used (or allowed) in productions for advertising purposes, the commercial set is inherently a place of higher risk, due to the sheer number of crew within a confined workspace, electrical cables running between areas, overhead rigs above crew and actors, and sharp, heavy equipment placed throughout cramped spaces and dark corners. All these factors—and others—pose an element of risk of injury to people on set, and it is important that everyone take safety on set seriously.

Steps to ensure the safety of your productions:

1. **During creative development:** Ensure that you, your production consultants, and your production partners review creative concepts while keeping in mind the potential risks associated with the script, as well as how the budget allocations and schedule must flex to accommodate safety best practices.

2. **Shooting around the world:** Ensure that your agency and production partners are aware of local safety practices and laws. If you have concerns that certain countries enforce lower standards of working practices—especially when there are risks that have been identified—then it is necessary to ensure that elevated standards are reached either through setting rules or providing additional protocols for your shoot. This may include an investment, such as adding another shoot day, instead of running too long a day, which may affect the wellness of cast and crew.

3. **Pre-Pro Meeting:** Pre-Pro Meeting agendas should include health and safety as a discussion item. It is a best practice to request that the line producer or assistant director identify any possible risks and define mitigation measures that will be taken throughout your production.

4. **On set:** The assistant director (AD) is responsible for safety, but may not be liable in the event of an incident. Different countries have different laws. For example, in some countries, it is the producer who is legally liable. Be aware that there may be other safety officers on set, depending on the requirements of the local jurisdiction and applicable permits such as fire fighters or police officers.

5. **Insurance:** Your agency producer and production consultant should be familiar with insurance coverage and the corresponding accountability of the brand or agency in the event of an accident, so that they can address any issues before and as they arise. Each project will have different permutations related to insurance. The brand chooses the method of insurance, and insurance can be provided through their own corporate wrap-up policy, the creative agency, an agency holding company, or the production company.

6. **Prior to the start of each shoot day:** The AD will start the day with a safety briefing for the crew. This is typically a mandatory meeting, requiring everyone in attendance to agree to safety protocols.

 a. At the safety briefing, the crew is informed of any unusual activities planned (stunts, pyrotechnics, special rigs, etc.), warned of the dangers, reminded to be alert, and informed of to whom they are to report issues. Any department heads managing risks will have the authority to stop filming if they deem that they are being asked to try anything unsafe.

 b. Clients and the agency often arrive after the crew safety briefing (since their call time is usually after the crew call time), so please require that everyone be briefed upon arrival by the AD or second AD to reprise the watch-outs for the day. Let your agency know that you expect to be informed and included in a safety briefing, and the production company will accommodate.

7. **Most production bids include a medic.** Make sure to review the call sheet for each shoot day, and ensure that a medic is on your set. The medic should be identified at the daily briefing. It is a best practice for the call sheet to also note the nearest hospital to the shooting location or studio.

8. **Be proactive.** If you see something, say something. Sets are dynamic workplaces, with many things happening quickly and concurrently. If you spot something of concern (an unweighted stand, an uncovered sharp point, cables one could trip on, etc.), alert production immediately.

9. **Do not sacrifice safety for the budget.** As brands utilize more low-cost production options, safety is not an area on which to skimp or cut back resources. Many low-cost productions utilize less-experienced production personnel working long and tiring hours; this is a risky combination that may quickly lead to safety issues.

10. **Make sure to get a risk assessment pertaining to your location.** Work with your production partners to determine if there's a chance that your shoot may be affected by incidents involving local syndicates, political, and/or civil disruption, and define alternative plans should changes to the location need to be made.

While the production company and their crew are responsible for providing a safe working environment, you do ultimately bear some responsibility as the marketer, since you are funding—and possibly insuring—the production. It is critical, then, that you set the expectations for safety on set. We recommend safety language be included in your production-bidding guidelines to ensure that bidders understand that set safety is a high priority; this also enables you to include the appropriate resources and protocols in your costs.

NEED TO KNOW: ON SET

Here are some things to keep you and your team focused while on set:

❏ Require on-set production-crew safety briefings at the beginning of each shoot day.

❏ Shoot the approved content first! Don't go rogue; if time allows, you can explore alternate scenes, takes, or shots.

❏ Identify scenes of critical importance, which may involve more scrutiny, and be available when it comes time to shoot these scenes/shots.

❏ Review the daily shoot schedule; understand possible impact of adding any new or alternate scenes.

❏ Ensure that all decision-makers are available for content-capture approval at each camera set-up and before moving on to the next set-up (as it is *very* difficult and expensive to go backwards once you have moved on to the next set-up).

❏ Implement a "No Surprises Principle": let everyone know that overages and cost overruns must be approved *before* they are incurred. Remember that the marketer is **responsible for overages for two reasons *only*:**

 a. Marketer-requested changes after award

 b. Weather, postponement, or cancellation

You have to get into the habit of asking what something will cost whenever you make a request. You can even ask, "Can I assume this will not trigger an overage?" Don't just assume your request will be absorbed by the supplier. Your agency assumes that, if you are asking for something, you are aware that you will be responsible for the cost, whatever it may be. So ask for the costs associated before agreeing to that additional shot or change!

Real-Life Story:

A marketer for a big-box retailer was attending a three-day shoot. At one of the locations, the marketer didn't feel the dining room was dressed appropriately and felt it would be better with a more modern look. The production company said they could push the dining-room shot to the next day, giving them time to re-dress.

The next morning, the agency producer approached the marketer with a $35,000 overage. The marketer was stunned! Why would it cost so much—and, for that matter, why would it cost anything? The crew had to work overtime. More crew personnel had to be added. They needed an extra truck, extended location hours, and additional set-dressing rental. The marketer said that if they had known it would be so costly, they would have stuck with the original dining room. The agency assumed the client would be comfortable with any cost, which turned out to be untrue. In the end, the client had to cover the cost for a scene that never even made it into the spot.

Post-Production

The shoot is over, and it's time for post-production, which is the final stage before the content gets delivered to the media channels. Post-production is quite different for each media type, so we'll break it out between video and photography.

Of course, don't forget about social assets! Tailor the post-review process to the medium in which it will live. Content for social should be viewed on a small screen/mobile device/in-situation and viewed through the lens of immediacy.

Post-Production: Video

Post-production encompasses the entire editorial process—from the creative edit through final content delivery, including music, visual effects, and sound design. The same process is followed when you're not capturing any new materials, where you are only repurposing existing footage or using stock footage. The details below describe this entire post-production process in more detail. It is important to determine which steps you or other stakeholders will want to participate in or approve. Note that skipping required approvals can result in additional time and money for changes made outside of the linear process below.

Any of these factors can impact the timing and costs of producing your asset. The rough-cut stage is an important moment in the production, where you finally see the vision come together. but it is just a "rough" draft, and there may be creative elements missing.

Key factors in the approval process that can impact cost and delivery:

▸ Number of people involved/client levels of approval

▸ Number of changes

▸ Complexity of changes

▸ Timing of changes

Motion Post-Production Process

Everything that happens after a live-action shoot is called post-production. It encompasses the entire editorial process from the creative edit through final content delivery, including music, visual effects, and sound design. The following describes this process in more detail.

Please note that phases can overlap or occur concurrently.

Offline Online

① Offline/ Rough Cut

▸ Low-resolution edit for client approval, representing select scenes and timings with no color correction, rough audio and temp or WIP graphics (GFX/VFX).

▸ This is the time to comment on scene selection, pacing, music direction, and design of supers.

② Color Grading

▸ Process of creative enhancement and color corrections. Approved edit is assembled to create the final look and balance color across all scenes.

▸ Occurs prior to finishing

③ Graphics (CGI)/ Visual Effects

▸ Graphics (GFX) includes 2D/3D supers/titles either animated or static, which require approval on design and timing. VFX can encompass compositing scenes or creating computer-generated imagery (CGI).

▸ See Animation/Visual Effects slide in this section for definitions and cost implications.

④ Audio/Music Sound Design

▸ The Rough Cut will include a "scratch track" with a demo or temp voiceover (VO), sound effects (SFX), and/or music which represents the direction and tone intended for final mix. Align on music direction and voiceover prior to final audio mix.

▸ See Audio/Music Section for more details.

⑤ Conform/ Finish

▸ Full-resolution assembly of all finished elements, including color-graded scenes, GFX/VFX, final mix including VO, SFX, and music for final delivery.

▸ Client approval leads to trafficking for distribution

Picture Lock

1. Offline Edit/Rough Cut/Client Fine Cut Screening
 a. Low-resolution edit for marketer approval, representing select scenes and timings, with no color correction, rough audio, and temporary or work-in-progress graphics (GFX/VFX). Keep in mind, the rough cut may be further along in virtual production, where much of the post-production is addressed in pre-production.
 b. This is the time to comment on scene selection, pacing, music direction, and design of supers. Do not leave the offline phase before making all your changes. The implications of changing edits further into the process can be very costly.
 c. The offline edit will include a "scratch track" with a demo or temporary voice-over (VO), sound effects (SFX), and/or music, which represents the direction and tone intended for final mix. Be sure to align on music direction, and choose the voice-over actor(s) prior to finalizing audio in the next phase.

2. Online and Finishing:
 a. Color Grading: process of creative enhancement and color corrections. Approved edit is assembled to create the final look and balance color across all scenes. This occurs prior to finishing.
 b. Graphics (CGI)/Visual Effects): graphics (GFX) include 2D/3D supers/titles, either animated or static, which require approval on design and timing. Visual effects (VFX) can encompass compositing scenes or creating computer-generated imagery (CGI).

Animation/Visual Effects

The complexity of animation and/or visual effects (VFX) will have a dramatic effect on costs and schedule. A 2D or 3D animated-only spot (no shoot) can be significantly less expensive than when combined with a live-action shoot. A live-action shoot with VFX can be one of the most expensive production types. The process includes phases of development, design, and production which require timely client approvals throughout.

$

CGI (computer generated imagery) STILL
▸ CGI production of still content such as product shots, characters, backgrounds, and branding
▸ Fairly inexpensive

$$

2D Animation/Motion Graphics
▸ Production of graphic content and backgrounds in a 2D (flat) space
▸ Used for branding to animate logos, text, end tags, and supers
▸ Faster and less expensive to produce than 3D

$$$

3D Animation
▸ Illustrates and animates 3-dimensional objects, characters, or entire scenes
▸ Scene dynamics may require complex movement and layers of animation
▸ Used for 3D modeling of movement of logos, product, liquids, characters, etc.
▸ More time and resource intensive than 2D

Stop Motion
▸ Capturing images one frame at a time, and assembling into a motion sequence
▸ Typically involves a live-action tabletop or stage set-up over numerous shoot days
▸ Time intensive — can be expensive

$$$

$$$$

Visual Effects (VFX)
▸ Combination of live action, CGI, and post-compositing techniques to achieve the creative concept
▸ Can involve green screen, matte paintings, set extensions, environmental elements, and enhancements, including: Glass shattering, explosions, sky replacement, etc.
▸ Can be the most expensive

c. Audio/Music/Sound Design: Original music, licensed music, or stock music will be added at this time and finalized, along with any SFX and sound design.

d. Conform/Finish/Master Completion: Full-resolution assembly of all finished elements, including color-graded scenes, GFX/VFX, final mix, including VO, SFX, and music for final delivery. Once the marketer approves the finished ad, the asset goes to trafficking for distribution.

3. Transcreation/Versioning/Adapts (Post-Production 2 [PP2]):

a. Once the master is completed, it's time to work on all the different versions, lifts, adaptations, etc. This will require far less creative oversight than the original master and will usually be led by a transcreation production agency.

b. It is imperative that a list of all the necessary versions be included before this stage begins. To state the obvious: you have to know what you're producing before you produce.

Pro Tip:

Tailor the post-review process to the medium in which it will live (for example, watch it on your mobile device if it's a social ad).

So, How Do You Review a Rough Cut?

We recommend you watch the video at least two times, first as a consumer to get your gut reaction, and then as a strategic marketer.

- ❑ Does the ad communicate the brand message and strategy?
- ❑ Does it execute the storyboard, and do you understand the story?
- ❑ Is the brand identity communicated clearly?
- ❑ Are you aligned on scene selection and pacing of the edit?
- ❑ Are you aligned with the agency on the direction for music, audio, and graphics?

Regarding revisions to edits, the following criteria should be considered:

- ❑ Are we making subjective changes, or are they actually and objectively improving the commercial?
- ❑ Will it make a difference to the consumer?
- ❑ Is the cost worth it?

When giving feedback on the video:

- ❏ Give an overall reaction first; do you love it? Is it hitting the brand strategy? Is it meeting creative expectations?

- ❏ Give specific comments in priority order.

- ❏ Articulate any problems. Do not provide a solution—that's the creative team's job.

- ❏ Aggregate comments from all marketer stakeholders, and provide one set of feedback to the creative team (as opposed to comments in succession, which might cause confusion or contradict themselves).

- ❏ Understand how many rounds of changes are included in the budget for marketer revisions, and track if the requested changes have been made or ignored. It is a common complaint that the rounds of changes available are used up by the creative team, not the marketer, and then marketer-requested edits are viewed as overages.

Before the picture is locked and final approvals are made of the rough cut, remember to discuss the approach for color correction, visual effects, sound design, audio, and music with the creative team.

Any changes to the video (alternate shot selection) made after final rough-cut approval may result in additional time and costs.

Post-Production: Still Images (aka Photography)

Post-production for still images, or photography, is the process of creating the deliverable by retouching images for final output via studio services. Below are the additional elements included in studio services that are negotiated and estimated separately from the photographer's production estimate.

Post-Production: Still/Photographys

 Selects/Retouching

Once the final images are selected, retouching will occur. This may be provided by the photographer, in-house agency or a third party. The agency should provide the number of rounds of review and revisions in the estimate to be sure it is aligned with the budget.

 Mechanical Assembly/FA (Finished Artwork)

The master mechanical is the final layout file, which includes all of the components of the final deliverable: hero image, product shots, logos, copy, legal, etc. built to the specific size, resolution, and color mode. All printed materials will require a mechanical.

3 Resize/Version (Adaptation)

Once your master mechanical is approved, it will be versioned and resized to fit all sizes per the media plan needs. These versions are referred to as adaptations, which include language translations.

4 Quality Control

Quality Control is part of every post-production workflow. This includes confirmation of all specifications required for quality reproduction. Edits at this stage may lead to increased costs.

5 File Delivery

Depending on the distribution channel, the files will be uploaded to the media partner, who confirms delivery and file compliance.

Photography costs are estimated by the number of images and the level of complexity.

Photography Complexity Chart

 Media

What is your media plan? (magazine, newspapers, social, POS, ecommerce OOH, web banners, etc.) Where will the assets be used?

 Master

How many master mechanicals are required to fulfill your media plan?

 Adapts/Amends

How many resizes and translations (adapts)? An example of a high-level adapt is resizing a single page to spread.

How many minor edits in an existing size (amend)? An example of a low-level amend is changing a headline, logo, or pack shot.

 Images

What is the total number of images?

What will be retouched, color corrected, composed (adding single images together into a larger group with shadows and/or highlights)?

 Distribution

What publications?
What suppliers?
What regions?
What Digital Asset Management system?

NEED TO KNOW: POST-PRODUCTION

❏ Know what you are reviewing and approving at each meeting.

❏ Provide timely, aggregated feedback (within 24 hours).

❏ Prioritize requests.

❏ Recognize the impact of revisions to "locked" or previously approved elements.

❏ Understand that a project is based on adhering to the schedule and scope at the award. Adding scope or making changes after the job is awarded may impact the project cost and delivery date significantly.

Notes

"I'm gonna need a signature
for this commercial!"

Delivery

DELIVERY
Delivery: Trafficking

All of your assets and ads are now approved and ready to go live. The assets, toolkits, and elements should be delivered to their final destination. The agency or distribution vendor will traffic (send instructions) and distribute your ads to appropriate media channels.

Need to Know: Delivery

It's important to make sure your agency producer or in-house producer does the following:

▶ Approve all contracted deliverables before processing final payment to production suppliers.

▶ Reconcile production estimates with final costs and in accordance with the production contracts and payment terms.

▶ Upload final assets to a central repository (Digital Asset Management (DAM), Content Management System (CMS), etc. Ensure the success of the library by:

 · Hiring a dedicated Content Asset Librarian to manage the repository

- Developing Asset Guidelines, which allow content creators, marketers, and other users to quickly and easily search for assets

Job Wrap/Reconciliation:

As a best practice, you will want to reconcile your production estimates within 90 days of delivering the assets. The reconciliation ensures closure, helps facilitate any conversations around unreconciled costs, and helps all stakeholders recognize the end of this particular campaign production. Any further investments or changes in this campaign should necessitate a new job estimate.

On complicated campaigns or campaigns that utilize new creative and/or production partners, we recommend the whole team get together for a post-mortem meeting to review what went well and what could have gone better. This ensures a healthy dialogue around issues, challenges, and better ways of working for future projects. All partners will find it helpful to recognize learnings and a better path forward.

A sample agenda for this important meeting is included in the appendix.

COST DRIVERS/TRAITS

Now that you are familiar with the production process, this chapter will review the cost drivers, which are the main traits that can increase or decrease your production spend. Understanding these complexities and variables will inform and provide guidance during creative reviews and production discussions to better manage your budgets.

1. **Setting Budget Parameters**: It is important to provide budget parameters to the creative team during the planning and creative-development phases, reducing the chance of receiving creative concepts that are over budget, which can result in added time and expense. As mentioned in the Planning section of this book, these parameters should be provided in the project brief, which should define the goals, strategies, budget, and, most importantly, a detailed set of deliverables. The brief also sets expectations for all participants, including the creative and production teams, and all production suppliers. When your plan and budget are clearly detailed and articulated, all parties are more likely to be aligned. A poorly defined project plan/brief can directly impact the success of the project and final costs.

Best Practice:

Start with a written project brief, and schedule frequent production meetings to ensure everyone is on the same page throughout the process.

2. **Creative**: Is the creative idea simple or complex? The style of creative (sometimes referred to as "genre" for video and photography shoots) is the base upon which all other costs are dependent. For example, you could be shooting monologue,

dialogue, multi-scene vignettes, tabletop, or other genres of deliverables, exclusively or in combination.

Best Practice:

Insist that your team provide a ballpark sense of costs when they initially present you with a creative idea. This doesn't mean a detailed production estimate but a general sense of the price range. Ensure that the ballpark is verified by an expert as realistic and, because things change, *revisit the ballpark up until award.*

3. **Complexity:** The complexity of the production is directly correlated to a project's costs. Factors can include number of actors/talent, celebrities, minors, animals, performance requirements, stunt performers, number of and types of locations, distance between locations, sets, number of scenes per spot, and sequences requiring animation and/or visual effects. The more elements in a production, the greater the cost and time necessary to get it produced.

Best Practice:

Plan for an integrated production to capture content for all media types and formats, produce more than one spot at a time (aka "bundled productions"), or leverage a single location by creating multiple set-ups that appear to be separate locations.

4. **Resources:** The team size and seniority, whether agency or supplier resources, is a cost driver.

> ### Best Practice:
>
> Make sure the skill level of your resources matches the project complexity—check the ratio of senior to junior staff members; sometimes, depending on the nature of the production, you might be able to use more junior-level workers with senior-level oversight, such as on transcreation work.

5. **Suppliers:** There are different tiers and levels of directors, photographers, editors, social influencers, etc. The budget will drive the vendor-pool selection. The level of supplier talent will impact your production costs. You should insist that the creative team present appropriate suppliers based on the creative and budget parameters. Understand that high-end directors may insist on preferred crew members and larger crews, as well as higher markups, and they may be less willing to negotiate. Their production companies may be beholden to crew-union guidelines.

> ### Best Practice:
>
> Be sure to competitively bid when appropriate and/or negotiate preferred rates with in-house agency studios.

6. **Schedule/Approval Process:** Allow enough time to produce and understand factors that impact your schedules. Rushed schedules could result in limited planning time, overtime, single-bidding, and other additional costs. The number of people and revisions in the approval process, as well as the timing of the number of changes and the type of changes, will also have an impact on the efficiency and budget of a project. To put it simply: **more opinions = more revisions = more cost and time.**

Best Practice:

Streamline your approval process, have simultaneous reviews, and provide consolidated feedback.

7. **Country of Production:** Where you shoot your video or photography can be a big cost driver or optimizer. Each destination will offer different benefits or challenges that will trickle down through the budget. Offshore locations in lower-cost production centers can provide significant financial advantages but may require more preparation, production time, or fees or costs. Potential budget impacts might include exchange rates, travel costs, taxes, insurance costs, local industry standards, crew wages, and talent-usage rights. Worth considering are locations (countries or US states) that offer production tax incentives for commercial productions.

Best Practice:

a. Explore and discuss location options during the pre-bid phase so that you have enough time to consider your options.

b. For more on tax incentives, see page 115.

8. **Talent:** Talent is one of the biggest cost drivers over the life of your ads. The number of talent, whether you're producing union or non-union talent, the classification of talent, the media plan and length of use, the type of talent (such as celebrity/athlete, social influencer, etc.) are all contributing factors. See Talent section for more details, page 100.

Best Practice:

Make sure to get ballpark estimates for talent with usage fees based on the projected media buy.

9. **Usage:** The right to use the deliverables produced is part of the production strategy. It is important to negotiate the rights to use your assets in the ways in which you want to use them. Leave nothing to be assumed, and ensure you do not wait until the end of the production to determine the costs for the usage rights. I have seen many a situation where the produced asset could not be used because the cost to use it was beyond the marketer's budget. The asset produced may have many different types of usage rights wrapped up in the final assets, including the rights for the actors/talent, puppeteers in some countries, fonts, stock footage or images, and music or other audio tracks, all of which generally have additional costs based on use. Understanding the different elements and the associated usage rights is essential to successful negotiation for the life of the asset. See Usage Rights section for more details, page 111.

Best Practice:

a. Always negotiate the usage rights upfront; ensure that each component is negotiated, and the timing, territory, and type of usage is clear, and that options are agreed upon upfront for additional usage.

b. Explore the use of existing assets to create new assets as a cost-savings option.

10. **Markets/Transcreation**: Transcreation is the process of adapting a message from one language/region or country to another, while maintaining its original intent, style, tone, and context. When producing for multiple markets, it is recommended that the number of deliverables, edits, adaptations, and digital formats are defined up front and prior to bidding.

Best Practice:

It is often optimal to consider transcreation services for multi-market adaptations over a standard agency-production approach. A transcreation partner who specializes in this work can be more cost effective than a traditional ad agency or high-end post-production vendor by 50–90%.

NEED TO KNOW: OPTIMIZING YOUR PRODUCTION SPEND

❏ Provide budget parameters prior to bidding, and adjust as specifications change.

❏ Ensure that you have a usage-rights strategy in place for talent, music, footage, etc.

❏ Early alignment of deliverables to support the media plan is imperative. Define objectives and scope before bidding, and finalize in a Pre-Bid Meeting.

❏ When reviewing creative, identify opportunities to leverage existing assets (reuse and repurpose), to avoid producing video or photographs already in your library.

❏ Choose to make more cost-efficient creative choices if and when possible, such as using stock music instead of licensed popular music, using less on-camera talent, shooting in low-cost production centers, etc.

❏ Competitively bid with two or more suppliers when possible.

❏ Set up preferred-partner programs to put in place rate cards, preferred-vendor rosters, vendor rebates, volume discounts, multi-year agreements, etc.

❏ Bundle and/or integrate productions and/or assets to get more from your production costs.

❏ Produce in low-cost locations or leverage state and country commercial-production incentives.

❑ Be mindful not to overproduce, especially your social media content. Ensure that you are choosing the appropriate supplier for the work, and don't spend more on production than on your media plan to support your overall content-production strategy. Be sure the juice is worth the squeeze.

As a marketer, you are funding the production, and you have the right to:

The Marketer's Bill of Rights

1. Receive unbiased recommendations

2. Ask questions

3. Say no

4. Ask for alternatives

5. Fee transparency

6. Have enough time for feedback

7. Know the consequences of a timeline delay

8. Have overages disclosed in advance

9. Receive complete and useful updates (call reports, status reports, project timelines)

10. Be informed of conflicts of interest among your partners

Notes

Notes

SPECIAL CONSIDERATIONS

There are *other topics or specialty areas* included in a production project that need your attention and special consideration. This is intended to give you an overview into each of these topics.

Why Are There So Many Producers On My Production?

You may observe that there are many producers involved in your video production, so it will be helpful to understand who they are, what they are doing on your behalf, and whom to approach for issue resolution.

Producer from Ad Agency Producer from Production Company Producer for Social Media Producer of Lattes Producer of excuses

The formal definition of a producer is a person responsible for the financial and managerial aspects of making of a movie or broadcast or for staging a play, opera, etc.

In the advertising industry, the creative agency is accountable to the brand marketer to ensure that the needs of the production are met and that the budget is divided appropriately between the creative and production suppliers they are managing. Typically, the creative agency assigns an Agency Producer (staff or freelance) to the project, and that producer has day-to-day oversight of the entire production, including suppliers subcontracted by the agency on the brand's behalf.

The **Agency Producer** may have other titles, including **Content Producer, Sr. Producer**, or **Executive Producer**—usually dependent on their hierarchy at the agency. The Agency Producer on your project may report to a more senior person who is also a producer and who may have a title such as **Sr. Executive Producer**, **Head of Production**, or **Chief Production Officer**. The Agency Producer is in charge of delivering the scope and maintaining the budget, priorities, and schedule for the creative agency on your behalf.

Similarly, the suppliers subcontracted by the agency, or directly by the brand, will also have producers responsible for the financial and managerial aspects of their company's role in your project. These will include the video production company's **Line Producer**, who oversees the video capture on set and, in turn, for the production company **Executive Producer**, who oversees the bidding, contracting, director, agency, and client relations. The **Line Producer** runs the on-set communication between the production company, the Director, and the agency. The Line Producer is ultimately responsible for delivering the scope and maintaining the budget, safety, and schedule for the production company.

Other producers on the project may include a **Post-Production Producer** for the editorial supplier, a **VFX Producer** from the Visual Effects supplier, and a **Photography Producer**, who oversees the budget, workflow, and crew for the Photographer (if happening simultaneously on your video set). There will be **Assistant Producers**, **Associate Producers**, maybe even a Producer for behind-the-scenes footage or for a B-camera crew, and, finally, there could be a Producer from your In-House team, should you be working

with an internal agency or have a client-side production studio involved. Depending on your audio needs, there may also be an **Audio Producer** or **Music Producer** involved in your project.

You get the idea; there will be lots of people with the title "Producer" associated with or connected to your project. Depending on your project needs, some of these producers will be on set, and some will be behind the scenes. Some you will meet, and some you will never get to know. Typically, all producers are listed with their company name and contact information in the project's pre-production book, which is prepared by the production company and reviewed by the Agency Producer of the creative agency.

Audio and Music Production

Audio: Audio advertising can be a stand-alone production (such as for radio and podcasts) and is often part of the video post-production process. Producing a radio spot or podcast follows the same process as producing other content, except that the timelines are shorter, and the casting/talent includes only a voice-over (VO) or live announcer.

Music: Below is a reference guide with the three types of music used in advertising. The budget and creative concept will dictate the approach to music production. My friend and expert Richard Kirstein, of the United Kingdom, has written a very useful guide to music licensing, called *Music Rights Without Fights*. I recommend you pick one up if music is part of your creative production strategy.

Stock Library	**Original Score/Jingle**	**Licensed**
‣ Stock (also called "library music" or "needle drop" is music that's available to anyone to use (public domain)	‣ Original score is created for commercial use and preferably owned outright by the client	‣ Licensing a popular piece of existing music is usually the most expensive and requires the most time for negotiation
‣ No exclusivity (you might hear this piece of music being used by another Advertiser) since you do not own	‣ It should be standard practice for the advertiser to own the music outright as a "work for hire"	‣ It requires purchase of 2 "sides":
‣ You can pay more for additional territories, media uses, and lengths	‣ A lower rate can be negotiated if ownership is relinquished, but marketer should be advised and part of the decision	1. Song or Publishing rights, meaning rights of the composition (who wrote the song)
		2. Master recording (rights to whoever recorded it)
		‣ For cost savings, marketer can pay to have the song re-recorded with an unknown band

NEED TO KNOW: MUSIC AND AUDIO

☐ Creative teams should provide a clear creative vision, with direction, and confirm they have alignment from the marketing decision-maker prior to bidding music and/or sound design.

☐ In the US, most content is owned by the brand group who is funding the project. It is very important to include this expectation of ownership, often defined under "work for hire" language in the agreement.

❏ Multiple musical options should be presented—not just one song. This will likely protect the project from falling apart if it is not possible to buy or license a particular song.

❏ Popular songs that either cannot be used or are out of the budget range should **not** be presented as an option.

Pro Tip:

Avoid "demo love," i.e., falling in love with an expensive licensed piece of music early in the process that will not be available or affordable.

❏ Approve voice-over casting prior to recording the voice-over.

❏ Approve the approach to music direction during the bidding process. Will it be originally composed music, licensed popular music, or music from a stock library?

❏ Ensure that the final copy can be read in allotted time. (A 10-second ad should be a 10-second ad.)

❏ Finalize scripts (including legal feedback and disclaimers) *before* recording sessions.

❏ If using licensed music for a campaign, think about negotiating rights for radio/audio in the initial agreement or as an option to be exercised at a later date.

❑ Engage a musicologist to evaluate a re-record of an existing, popular song to ensure the new version meets the requirements and doesn't appear to be a copycat version of that song.

❑ If re-recording a popular song (a cost-effective approach to licensing a song), be sure to avoid using "sound-alike" tracks or singers. It is okay to use an existing track as a reference as long as a musicologist is comfortable that it is significantly different from the original and will stand up as such in court.

Talent Overview

Talent refers to the performers and actors appearing on camera or as voice-overs—the people/images and/or voices seen/heard, including singers and musicians, puppeteers, and stunt performers.

Talent is paid for both their performance day(s) and the usage of the finished asset. Together, the talent costs are referred to as the "Talent Payments."

Talent payments can vary, based on the country in which it is produced, any union or associations regulations, the media-distribution plan of the content, and usage rights/ duration terms negotiated with the talent.

A business manager or producer oversees all of these details. Your role is to be aware of the talent aspects and have a dialogue with your creative-production producer about the budget implications of both the day rate for the production days and the usage costs.

Union vs. Non-Union Talent

If you are producing under talent union jurisdiction, rates are pre-determined and based on contracts. There are many rules.

Union Talent

▸ The US and Canada have strong talent unions, with fee, guidelines, and usage mandates.

▸ Other countries have strong talent associations that set the rates and working guidelines in their jurisdiction, such as Argentina and Australia.

▸ Rates are pre-determined and based on signed contracts. It is the agency's responsibility to ensure that all paperwork related to talent (both union and non-union talent) is reviewed and finalized prior to shooting. Since the agency is acting on your behalf, they should be reviewing the terms of the contracts with you prior to finalizing. This is an important step to ensure that you are going to be able to use the finished or final assets in the ways in which you desire, and to understand the costs and any limitations involved. This is where a production consultant will come in handy.

Non-Union Talent

▸ The majority of countries around the world producing motion or audio/music content do not have union affiliations.

▸ Still photography is not governed by unions in any region or country (yet).

▸ All rates and fees vary by region, as do the taxonomy and classifications of talent (e.g., on-camera, off-camera or voice-over [VO]), background, featured extras, etc.)

▸ Wages and working conditions may be governed by local/federal laws, depending on the country.

Key Stages When Talent Costs Can Be Affected

Your talent budget is determined by the number of talent personnel, the key roles, number of workdays/hours, plus usage terms, and applicable taxes and service fees. Understand which costs are included in your talent estimate; ask questions early. Below are the key stages when talent costs could be affected.

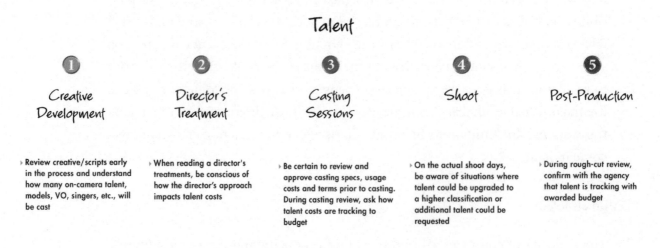

Talent

1 Creative Development

▸ Review creative/scripts early in the process and understand how many on-camera talent, models, VO, singers, etc., will be cast

2 Director's Treatment

▸ When reading a director's treatments, be conscious of how the director's approach impacts talent costs

3 Casting Sessions

▸ Be certain to review and approve casting specs, usage costs and terms prior to casting. During casting review, ask how talent costs are tracking to budget

4 Shoot

▸ On the actual shoot days, be aware of situations where talent could be upgraded to a higher classification or additional talent could be requested

5 Post-Production

▸ During rough-cut review, confirm with the agency that talent is tracking with awarded budget

NEED TO KNOW FOR NON-UNION TALENT:

❑ *Any* talent-cost implications should be shared throughout the production process and for usage of the final asset(s).

❑ In advance of casting, ensure that you receive a ballpark estimate for the talent costs, based on a proposed media plan. This is an important step, as it will help you to determine the ROI for creating your asset once you have the performance/results of that asset's life cycle.

❑ Your production team or business affairs manager should have a system in place to keep track of all the disparate elements, such as talent, music, stock footage, photography, etc., with usage terms, costs, and expiration dates. We refer to this as a usage-rights tracker.

❑ Background checks and social media checks are strongly recommended on non-union talent and social influencers, prior to production, to avoid producing something you can't use.

❑ Your producer should be keeping accurate, complete talent-contact details, in case of renewal and repurposing an asset in the future; it is best to attach a photo of the talent in wardrobe to the contract.

❑ If and when employees are used in your production as on-camera or voice-over talent, it is important to obtain certain corporate/human-resources approvals and follow country/union/association guidelines.

❑ When negotiating talent rates and terms, make the best attempt to follow these negotiating principles:

 a. Negotiate for a campaign (i.e., *all* versions, adapts, lifts).

 b. Separate the day rate from usage fees, so that when you renegotiate for future options, it is only on the usage fees and does not include the production shoot-day costs.

 c. Negotiate for all media across platforms (TV, print, internet/digital, social, experiential, in-store, etc.).

 d. Usage term should start from the date of first use and, ideally, last for three years, with options defined up front for renewal.

 e. Be sure to obtain a buyout of any product photography shots.

 f. Include and define additional use options in all negotiations.

❑ Influencers and celebrities also have contracts that need to be reviewed with these best practices in mind.

Augmented Reality / Virtual Reality (AR/VR) Production

As the marketing industry evolves to include new media, there will be a time when you will be faced with shooting an augmented or virtual-reality video. This form of storytelling has been widely used, and producing a story using "traditional" broadcast techniques will not suffice. Since the purpose of AR/VR is to replace or augment your reality, shooting for this medium will capture the entire 360-environment, rather than what is in front of the camera, as in traditional broadcast. Proper planning needs to happen prior to shooting, such as:

▸ What worlds need to be created?

▸ How are the backgrounds going to be built?

▸ Is it a live-action shoot or fully CGI?

It could be one or all of the above. The key to having a successful AR/VR shoot is to determine what the deliverable will be, how many end users will be able to experience this content, and on what device(s) the content can be viewed. Be sure to determine up front:

▸ Type of camera that will be used and how the story will be shot

▸ Number of mobile platforms for which this will be developed (many platforms have different specifications)

▸ Number and types of devices on which it will be viewed

▸ If there is a custom app that requires development

▸ Suppliers that have experience doing your type of project

▸ Increased costs of producing in 2D and 3D

▸ Required hardware for any kind of experiential event

▸ Custom sound design for this type of experience; plan to budget a bit more for this

▸ Talent needs and usage

▸ Production schedules' alignment, especially if there is app development and a long phase of testing

▸ Proper time for post-production and cleanup/stitching

Ensure that all of the above has been determined **prior to any pre-production,** and be sure to keep in mind your end-user experience and how your customers will engage with your content.

Virtual Production

Virtual production has revolutionized the world of filmmaking. So, what exactly is it? And why is it gaining traction in the movie, television, and advertising-production industries? Let's find out.

What Does Virtual Production Mean?

Virtual production is a filmmaking method that combines virtual and physical worlds to create scenes. You're probably familiar with the green screen and rear projection, which are tools often used to enable editors to change backgrounds through visual effects in post-production. The green-screen approach requires extra time during the post-production phase to marry the background image to the foreground action. Alternatively, rear projection is when a projector casts an image from behind a translucent screen behind the main action. Rear projection is often used outside a car while filming actors inside to give the illusion of a moving vehicle.

Virtual production provides the best of technologies. Like green screen, there's lots of flexibility on set to capture the main action. Like rear projection, you leave the shoot day with a finished shot, in which the foreground and background are married together. Virtual production provides the flexibility and efficiency needed in today's fast-moving content-creation space.

On a virtual production set, also known as a volume stage, what would have been a green screen is replaced by massive LED screens or live walls. The high resolution of these screens makes it possible for any video or image to appear hyper-realistic in the background. So when a camera captures footage of this screen, with the actors and props in the foreground interacting with the video background in real time, it looks

as if all elements are live and shot on location. It is possible to change the background quickly and shoot multiple locations effectively and efficiently in one day.

Some considerations for deciding if Virtual Production is right for your project

▸ Are there multiple shooting locations required that can be reached in a way that is more cost-effective and more eco-friendly than flying?

▸ Is the dialogue challenging and a high risk for re-shoots?

▸ Will weather be a factor and place limitations on the shooting location?

▸ Is there limited time with celebrity talent, requiring less travel time and a more planned, coordinated shoot?

▸ Is the physical location too challenging? Is the CGI not realistic-looking?

▸ Is there an opportunity to repurpose existing assets or create a virtual space that can be repurposed, such as a virtual retail environment or quick service restaurant (QSR)?

▸ Do you have enough time built into the schedule up front for proper pre-production and creation of assets, and coordination of VP elements?

▸ Is there a long-term investment strategy in creating a reusable background, such as a frequently used location or client store (for retail and QSR clients, for example).

What You Need to Know About Virtual Production to Be Successful

Common misconceptions about VP

There are fewer people on set. No, there are more people on set. While there may be fewer gaffers and grips due to a smaller set, shooting virtually does require a regular crew plus additional people in the virtual-art and VFX departments on set. Expect that there will be higher crew numbers than on location, although you could be saving crew travel time going to a distant location.

The setups are easier on shoot day. No, they are the same. VP is just another tool in the toolbox and encourages a more collaborative shoot with all crew and VFX. It requires that everyone work together prior to the shoot, so that everyone knows exactly what and how scenes are being shot on set.

Reshoots take a long time to set up. No, reshoots can be done very quickly on the same or different day when locations, lighting, and elements are programmed into the scene. This eliminates a lot of time, since setups are saved to the Brain Bar and can be pulled up on the screen within seconds, lighting adjusted as it was previously, and all shoot information stored.

There are a lot of experienced directors, ADs, and DPs. No, this technology is still in its infancy, so finding a highly experienced crew requires research into what needs to be shot and vetted, and proof of past VP projects. Currently, the community has very limited experience, but due to increased popularity, training is occurring in many cities and studios.

We can get our whole commercial using VP. In some cases, yes, although most of the time, there will have to be some part of the content that has to be shot practically. This

will be dictated by the creative, and you can never assume that, just because the stage is there, you will walk away with a finished commercial. There will always be some level of post-production, VFX, and cleanup, although this can be drastically reduced using VP.

Virtual Production will save us money. Yes and no. In certain instances, such as flying a crew long distance, having limited time with a celebrity, shooting in multiple locations, weather factors, and/or building a background (client store) that can be re-purposed, there will be cost savings. However, the size of the volume required, the number of shoot days, and the creative will dictate the price. Decisions to do VP should be based on solving problems, not just saving money.

We should use a production company for our VP. This will also be dependent on creative. If your project requires a top director who can get a performance out of a celebrity, then going through a production company will be a better choice. If that is not the main concern, VFX houses often have their own LED stages and volumes, and/or their own experienced directors who have worked with the technology and understand how it must be shot, in addition to being less costly than an A-list director.

VP is not a one-size-fits-all solution. Crew expertise and technology are still being developed. When considering a VP approach, you need to ask, "What problem are we trying to solve?" There are many instances where it is beneficial to use VP; however, there are also many cases in which it will not result in solving the problem. Each project is unique and needs to be analyzed carefully. The four main considerations are: budget, creative needs, the team involved, and the time needed up front. Planning is key for a successful Virtual Production.

VP is more sustainable. Sustainability requires time to develop into a natural part of your production approach. Given that it is both a creative game-changer and good

for our planet, APR feels it is important to include VP in your production strategy going forward.

Centralizing Usage-Rights Management

The magnitude of media channels has increased the demand for content, while the life span of an advertising unit is decreasing. Advertisers are challenged to create fresh content at a rapid speed and, as such, are increasingly repurposing existing assets.

> **Over the course of a campaign, an advertising message may contain the following elements:**
>
> **Video, animation, photography, illustrations, licensed music, original music, stock music, typography, licensed font, stock footage, stock images, cgi images, audio, talent, vr/augmented reality, consumer-generated assets, partnership assets, branded content, etc.**

In a traditional linear model, rights management was relatively straightforward, and brands/marketers relied on their creative agencies to negotiate and manage the usage rights associated with assets produced. However, due to the proliferation of content produced by a variety of creative origination sources and used across multiple platforms, screens, and channels, it is challenging to manage usage against various agreements and keep track of options as they are exercised.

Implementing a rights-management strategy can minimize the risk of costly usage and intellectual-property rights violations and eliminate the need to track down contracts, which can delay the creative process each time assets are repurposed.

Rights are licensed based on:

- ▸ Time in market

- ▸ Geographical territory

- ▸ Media placement

- ▸ Exclusivity (exclusive or non-exclusive preference in your category)

Exact terminology and standards may differ for various elements of a campaign. For example, while an advertiser may hold ownership rights to all footage shot for a video (as is usually the case for a video shot in the US), it is likely that rights to other elements of the video, such as on-camera and voice-over talent, stock imagery, and music will have limited terms for anything outside of the original use. Another example: in China, the Director owns all the video footage, except for the bits included in the final assets as approved by the brand and their creative agency.

How to Get Ahead of This Trend and Manage Risk

Taking the time to proactively establish asset guidelines and a rights-management strategy will provide assurances for ongoing brand security and mitigate potential risks.

1. **Create and implement a rights-management strategy for consistency within an organization:**

- Include the expectations in all creative briefs (strategy for usage-rights negotiation may vary, based on tiers, markets, and product).

- Remember that licensed agreements are between the advertiser and the artist/supplier creating the work and do not automatically extend to third-party partnerships unless specified in the upfront negotiation.

- Consider exclusivity definitions and requirements.

- Ensure that all licensed assets are covered for the same usage.

- Use clear language. Terms are not necessarily consistent across disciplines or markets.

- Create options for extending use at the time of the initial negotiation.

- Determine if any unions govern the collective-bargaining terms of an agreement.

- For work-for-hire agreements, consider creating a brand agreement for suppliers to sign.

- Track all contracts and terms in a central location.

- Ensure usage rights are built into the metadata of an asset and integrated into your DAM library.

- Set up a process for review of all assets coming up for renewal 30–60 days prior to the expiration.

2. **Develop an integrated-production toolkit, including:**

 - A process chart outlining rights-management strategy

 - Media checklists and social specs to ensure content is captured in the correct formats during production

 - A campaign asset tracker to house all terms and agreements with each individual artist, supplier, and agent

3. **Create infrastructure to allow for global capabilities for markets to reuse and repurpose existing content, which includes:**

 - Providing one central repository for assets (digital-asset management/content-management system, etc.)

 - Hiring a dedicated content-asset librarian to manage the repository

 - Developing asset guidelines that allow content creators, marketers, and other users to quickly and easily search for assets

4. **Centralize and streamline an internal approval process to clear assets, reduce the risk of usage violations, and ensure that content reaches the market quickly.**

5. **Evaluate the investment to produce new content against a percentage of repurposed assets to determine the value, benefits, and ROI.**

Tax Incentive Locations

Many countries and states in the US offer financial production incentives to advertisers who shoot commercials in their regions. The savings can be significant. Depending on the state's program, incentives can range between 10 and 40 percent of qualified production spend in that state. These locations and programs change often, so you should always check with a production expert.

Commercial-production tax-incentive programs are designed to provide economic stimulation and promote growth and job opportunities for the residents of a particular state. Tax-incentive programs started to appear about 30 years ago in the feature-film and television industry to counter US production from going offshore for lower costs.

Not all states offer tax incentives, and not all states offering tax incentives to the advertising industry are equal. Typically, rules governing tax incentives are written into law, have their own qualification structure, requirements, schedules, and both minimum and maximum spending limits. Tax benefits to the advertiser can come in different forms and include transferable tax credits, rebates, refunds, tax exemptions, and free goods and/or services.

Not every project is appropriate for shooting in an incentives state, but each project should be evaluated during the creative-concepting phase for incentives potential. It is important when considering shooting in an incentive location to assess the following:

▸ **Production Schedules:** Most of the programs need upfront consideration to ensure that you are following all application procedures. Ensure that you have the time in the schedule to meet required deadlines.

▸ **Production Infrastructure:** Returns are calculated on the amount of in-state spend. The more items (crew, equipment, etc.) you need to bring in from out of state, the smaller the qualifying spend (although some states will allow for certain out-of-state crew to qualify).

▸ **Talent:** Some states will allow out-of-state talent, including celebrity talent, to qualify. An assessment should be done to understand all factors and limitations before application.

▸ **Creative Needs:** A client's creative needs should still be executed to the highest level, irrespective of location. How will local weather, terrain, and talent availability affect this creative product?

All discussions regarding the incentive filing and how the credit is realized and distributed are at the client's discretion. We strongly suggest including language in production guidelines outlining ownership of incentives and a process for pursuing opportunities to ensure clarity and success.

It is important to remember that a credit won't necessarily lower the cost of the current production immediately, since it can take six months to more than two years from the time of production to monetize an incentive. Though the application can be complex and time-consuming, it can be worth sizable returns to invest in the effort.

Pro Tip:

State legislatures and government entities may change the details of their commercial-production tax-incentive programs at any time. Be sure to identify the most up-to-date information from the appropriate state entity or from an informed third party.

Notes

FOR THE MARKETING LEADER

This section is a top-line-production overview of today's modern creative-production approach, with a specific focus for brand leaders, including:

1. Decision-making and on-set etiquette

2. Respecting schedules; where there is flexibility and where there isn't

3. Marketing leader as a driver of social and sustainable practices in production

Decision-Making and Your Influence

Working Together. We know that powerful people can influence the process and the shared experience, so it's important to recognize this influence and use your power to improve the working relationships.

Fostering a working environment that serves everyone's collective end goals is the best way to get results. Treating people well will help uncover efficiencies and positive outcomes when negotiating changes. On productions, everyone must pay attention, listen, and work together to deliver the best work. We know that production teams will deliver if you empower them to do it.

When on set, there are protocols that will be reviewed at the start of every production. The Assistant Director or Executive Producer will gather you, your team, your creative agency or in-house team, and their crew to share their expectations to:

▸ Maintain a healthy working environment

▸ Get the most out of everyone's skills and talents

▸ Show respect and value to all team members

▸ Celebrate the wins and successes

Timely Decisions. It is also important to understand that your approvals and the timing of your approvals are key to keeping the production on schedule and on budget. The production team will need to know your availability for key decision points.

Requesting Changes to Scope. Sometimes it is unavoidable, and you may want or need changes in scope from the original plan. It is important to understand how the changes may impact the timing and the budget. If you have a request, you should not assume there will be no impact. Often, it's possible to get your changes addressed by shifting the schedule around, but that's not true in every case. You will be a hero if you ask for the impact of your requested changes and invite the team to discuss it openly. This will help to ensure you get what you want, and it will also help the production company and agency to navigate the options openly and transparently.

Code of Conduct

Respect is essential in production. Good relationships can yield more and better work; it will benefit you in your career as you build your network and own your role. If everyone agreed to support the following statements, it would ensure that communications and accountability are clear and that issues are dealt with on a regular and professional basis.

▸ I agree to support the decision-making process and commit to dates assigned to me in making timely decisions.

▸ I agree not to be disruptive to the production by changing my mind often and with no regard to the impact on the production.

▸ I understand that the freedom to change one's mind comes with creative territory, however, I will be accountable for the impact that my requested change(s) will have on the timing or costs of the production.

▸ I will be decisive and let my word carry weight. I will make good on my word. If something is approved (creative, costs, timing, or terms), it means it should move forward.

▸ I will take responsibility for my decisions and understand that people's time and efforts have value.

Marketing Leadership as a Driver for Social Change

Diversity, Equity, Inclusion, and Belonging (DEI&B)

We are seeing more and more global brand marketers setting strategic intentions to drive progress in DEI&B within their campaigns, including looking at their supplier mix, approach to storytelling, and on- and off-screen talent. We recognize that people, policies, and organizations must be held accountable and be compliant if the industry is to create lasting change.

For many marketing organizations, driving DEI&B throughout the creative supply chain may appear to be a colossal task. Data privacy and other concerns may discourage a brand from embarking on their DEI&B journey, but there are varied approaches that can be used to help measure and track self-identified individuals such as content creators and crew. Below are some best practices to keep in mind:

Marketing Operations/Organizational Support

▸ Be clear on your DEI&B ambition, and align your goals to those of your company/brand.

▸ Invest in the future by supporting the growth of industry DEI&B organizations and advocacy groups either by providing financial support or offering educational opportunities and/or mentorship programs for their members. Examples include Free the Work, AICP's Double the Line, Streetlights, Disability:IN, WeConnect International, Vets2Set.

▸ Mandate anti-bias training for all employees and agency partners supporting your business.

▸ Establish a "home" for all DEI&B activities to flow through, be it an employee, a team, or a "council." Recruit internal champions to form a community or task force to coordinate and execute activities, but be mindful of the additional workload you might be placing on an already-marginalized group.

Creative Development

▸ Partner with your agencies to embed DEI&B into your storytelling. Remember to avoid stereotypes; subtle messaging and attention to surrounding environments, including clothing, can be as important as bold statements and casting decisions.

▸ Have your internal DEI&B department/team/advisors review scripts, storyboards, director treatments, rough cuts, and social posts to ensure proper representation.

▸ Clearly define expectations for DEI&B on every production through agency briefs, guidelines, playbooks, casting, post-production, and music decisions.

▸ Be intentional with casting specs! Cast for a diverse range of races, ethnicities, genders, ages, abilities, veterans and LGBTQIA+, etc., but also be sensitive to the roles assigned to cast members of diverse backgrounds. Stay alert to the potential of unconscious bias.

Production/Execution

▸ Challenge your agency teams to look beyond their regular stable of directors, and require a rationale for each recommended director.

▸ Establish percentage goals for productions to be directed or photographed by women and/or under-represented persons. Consider mandating the inclusion of a woman and/or an under-represented person in every bid and everywhere possible. However, to really make an impact, your target should be defined as projects *awarded* to women or under-represented directors, not just including them in the bidding process. Be aware that bidding takes a lot of time and effort, and can

be taxing on the small business that is bidding and never winning the award of the work.

▸ Hire production companies (video and photography) that are certified as minority-owned businesses. Look for opportunities across all phases of production (shoot, post, VFX, music, sound, etc.).

▸ Source a minimum of two production assistants (or other roles) from industry organizations promoting the development and education of diverse talent. Consider programs that are aligned to your company's/brand's DNA.

▸ Require production companies to consider sourcing third-party services from women-owned and/or minority-owned businesses: casting, equipment, catering, stage, etc.

▸ Remember to include DEI&B crew in all phases of production: shoot, post, VFX, and music.

Production Sustainability

The industry has made significant progress in reducing carbon emissions, from sustainable messaging to production practices designed to reduce waste. But there is still work to be done. Below are some areas to consider that impact the carbon footprint of your production:

▸ **Travel:** Consider ways to justify or reduce travel, one of the major contributors to a production's carbon footprint. Virtual production and virtual shoot attendance can eliminate the need for travel altogether, while utilizing local cast and crew can reduce emissions.

▸ **Energy:** Look into renewable fuel sources to power your shoots, such as wind, hydro, or solar power.

▸ **Waste:** Mitigate production waste by doing away with single-use plastics, working with 100% recycled materials, using recycled assets, and sourcing food locally, when possible.

▸ **Carbon Offsetting:** Even with stringent policies in place, some emissions are unavoidable. Purchase carbon offsets to mitigate the damage caused by unavoidable emissions, bearing in mind that this should always be the last resort, favoring solutions that reduce or remove emissions in the first place.

While sustainability goals should be clearly defined and planned for, they do not have to be prohibitively expensive. With proper planning, some of these solutions can actually help save money, particularly where a reduction in travel is implemented.

Notes

Notes

APPENDIX

Sample Agendas for Key Production Meetings

Pre-Bid Meeting (Video/Photography)

Purpose

To align on key production specifications (specs) prior to engaging external production suppliers. At a minimum, these specs should include final scripts/storyboards, deliverables, bid specs, talent/music/third-party licensing specs, ballpark budgets, and production timeline.

Timing

To be held directly following final approval of creative as a kickoff meeting to the project.

Agency-Supplied Materials

1. Folder or document with agenda, aka pre-bid booklet

2. Supplemental materials (location photos, director reels/photography links, music samples, etc.)

3. Test materials (animatics, pre-vis, audio, etc.)

Key Discussion Points

1. **Script and/or Storyboard.** Review approved storyboards and scripts, lengths, and number of versions, including any/all aspect ratios.

2. **Approvals.** Confirm that all necessary approvals have been made (creative and legal).

3. **Vision and/or objective.** Discuss creative vision provided by the agency creative team.

4. **Special Approach.** Identify any special approach to production, including special effects and pickup footage (stock footage, existing footage for reuse, etc.).

5. **Bid Specs.** Review bid specs or bid letter(s) created by the agency producer/art buyer.

6. **Directors' Reels/Photographers' Links.** Discuss agency POV on director/photographer selection (criteria/skills). View directors' reels/photographers' links if available.

7. **Location specs.** Discuss location for filming. Consider offshore and tax-incentive options.

8. **Talent.** Outline the number of actors, including key roles, on-camera principals, background extras, union or non-union, celebrity, influencer, trained actor, real person, etc. Ensure enough time for background checks and negotiations.

9. **Casting specs.** Review written casting specifications for each character, role, or group.

10. **Exclusivity.** Determine exclusivity or competitive category(ies) needed for talent usage.

11. **Music.** Discuss music direction for bidding purposes (original, library, or licensed). If licensed music is preferred, review music specs and budget.

12. **Diversity.** Check for bias/stereotypes in script, and discuss diversity considerations with crew, production suppliers, post-production companies, and talent.

13. **Alternative Needs.** Leverage creative (find potential synergies with other divisions or print, promotions, or radio creative, Behind the Scenes, You Tube, Social, etc.).

14. **Schedule.** Include all stages of production (creative development, bidding, prep, shoot, animation, VFX, post-production/finish, approvals, and ship).

15. **Budget.** Confirm available budget with marketer; cover off any contingencies.

16. **Talent-usage fees.** Prepare estimates for talent-use fees and review budget at the Award Meeting.

17. **Any contingency.** Agency to provide alternative production plans and estimates for costs and/or timing should a global pandemic or political unrest restrict or impact production.

18. **Eco-friendly productions/sustainability.** Define eco-friendly production practices, carbon calculator tools, and measurement methodology.

19. **Other Considerations.**

 a. **Product.** Source and quantity of product. Where is the product coming from and who is responsible?

 b. **Special Props.** Wardrobe, signage needs, special production considerations. How long will these items take to produce?

 c. **Insurance.** Who is responsible for production insurance?

Award Meeting (Video/Photography)

Purpose

To finalize the selection of a director/photographer and/or creative partners and to commit to spend the estimated budget. Using an estimate template, the agency will clearly define what is included, and what the contingencies are, and address any execution questions.

The Award Meeting is a commitment to:

▸ Creative direction—Treatment and reel for recommended director/photographer (and competitive bidders as necessary) should be reviewed and approved.

▸ Confirmation for expectation of talent roles/costs/usage terms (may evolve in post and as media plan progresses)

▸ Financials

▸ Production and post-production suppliers

▸ Production schedule with milestones and rounds of review for marketer approval

▸ Marketer guidelines for billing, postponement, cancellation, and weather days, unless otherwise noted

Agency-Supplied Materials

▸ Agency estimate

▸ Recommended director's and/or photographer's treatment

▸ Casting and location specs

Key Discussion Points

1. **Scripts.** Approved script(s) and/or storyboard, legal review, and test results (highlight priority scenes, if applicable).

2. **Director/Photographer treatments.** Discuss the director's and/or photographer's approach and contribution to concept, as well as any details in treatment that affect execution or cost.

3. **Versions.** Alternate versions or "must haves," including all aspect ratios, cutdowns, adaptations, or lifts.

4. **Music.** Any information on music of which budget/timing should be informed.

5. **Creative approach.** Overall approach to production, including special effects and pickup footage (stock footage, previous product shots, etc.). Agency is encouraged to share references using existing or stock footage, or other audio/visual aids for demonstration and creative alignment.

6. **Casting.** Written production and creative casting specifications, including DE&I requirements (so the agency can move forward with casting upon award).

7. **Talent costs.** An estimated dollar amount as it relates to talent-usage fees.

8. **Exclusivity.** Confirmation of exclusivity categories needed for talent usage.

9. **Usage.** Identify usage issues, e.g., celebrities, voice-overs, internet, cinema, print, etc.

10. **Marketer-provided props, wardrobe, and signage.** Discuss any on-set elements to be provided by marketer (quantity and source). Allow enough time to facilitate requests.

11. **Schedule.** Make sure everyone is aware of the schedule and their commitment to provide input or approvals on key dates. (Include agreed-upon milestones and rounds of review for marketer approval.)

12. **Additional costs.** Any cost contingencies such as weather days/cancellations/postponements.

13. **Insurance.** An understanding of insurance coverage, including any riders, e.g., cast insurance

Production Status Meeting
(aka pre-pre production, PP1, or status call)

Purpose:

This is the time to flesh out the available production details that will influence the commercial execution and lead to prep work for creative team and suppliers. It should be considered a work-in-progress meeting. Any preliminary creative ideas that the director/photographer have contributed should be shared, and necessary approvals should be obtained as a follow-up.

Timing:

To be determined by you and your team, depending on the needs of the project. Usually via conference call and/or email.

Key Discussion Points

▸ Approved **storyboards** and test results (if applicable)

▸ **Alternate version** "must haves"

▸ Remaining **copy, legal, network, and R&D** issues

▸ **Overall approach** to production, including special effects and pickup footage (stock footage, previous product shots, etc.)

▸ Review **casting tapes**; select and book cast

‣ How will the **number of talent personnel** affect the overall budget?

‣ Confirm talent usage and options *before* negotiating (if non-union/offshore)

‣ Review **location photos and/or set sketches**

‣ **Align on wardrobe and props**

‣ **Product**—source and quantity of working product and hero packaging

‣ Any production items **needed from marketer,** such as product, signage, buttons, etc. Allow enough time to facilitate these requests.

‣ **Music**. Discuss and review music and sound design. Listen to available samples and rough tracks, if available. Review music production timetables, cost considerations, and opportunities to leverage music. Share music-related costs across various production platforms and among creative partners.

‣ **Schedule**

‣ **Confirm budget**

‣ Ancillary media considerations (copy, usage rights, production needs for internet, print, social, etc.)

Other Considerations:

▸ **Special prop and wardrobe** purchases

▸ Other special talent issues, e.g., celebrities, voice-overs, or purchased music

▸ Are there any elements of this project that can be used to leverage/repurpose?

▸ **Sustainable/eco-friendly** production

Pre-Pro Meeting (Video/Photography)

Purpose

To ensure that the agency, production company, director/photographer, and marketer have aligned their expectations and reached consensus on creative, strategic, and executional considerations. Pre-Pro Meetings should be conducted in a consistent and thorough manner, with the marketer, agency, director/photographer, and producer from the production company in attendance.

This is the final meeting prior to the shoot and is not the time to make significant changes, but to:

▸ Exchange ideas and interpretations of the concepts and objectives of the spot(s)

▸ Ensure that objectives and expectations are clearly represented to those who will be executing the video(s)

▸ Confirm brand-team commitments and decisions on appropriate production issues

▸ Provide technical advice to the agency and production company on product handling, company policy, and legal matters

▸ Approve or reject newly proposed expenditures

Any significant changes identified at the Pre-Pro Meeting need to go quickly through the necessary approval channels.

Timing

At least two business days prior to the shoot

Materials

▸ **Agency to provide** pre-pro book, including scripts, shooting boards, location photos, talent photos, and other necessary supplemental materials

▸ **Marketer to provide** final approval of cast, location, wardrobe, set dressing, key props, hero packages, and/or other significant production elements

Key Discussion Points

1. **Agency Creative**
 a. Review approved **agency creative** (scripts and/or boards).
 b. Commercial titles/length of spots.
 c. Confirm number of deliverables, ratios, and final script.
 d. Director's detailed shooting boards and/or shot list. Discuss additional shots/ angles or alternate versions needed with the director.
 e. Photographer's shot list.
 f. Any other content needs.

2. Set **safety procedures**

3. For **remote shoots**—comms process and expectations

4. **Final location** and set approvals (Set sketches and/or location photos)

5. Set dressing and props in detail (view photographs if available)

6. **Final casting approvals.** Review casting tapes, and finalize casting

7. **Final wardrobe approvals** (talk with stylist and examine wardrobe samples)

8. **Final props approvals**

9. **Review music and sound design.** The project will move quickly into post-production, so it is important to review and update music and sound-design considerations, specs, direction. Listen to samples, if available.

10. **Special considerations** (e.g., on-camera visual effects, lighting, post-digital effects, etc.)

11. **Logistics** for any marketer-provided props, wardrobe, and signage

12. **Review product handling** (hero packaging, logistics, special signage, etc.)

13. **Communications:** Determine on-set communications and shot-/content-approval process

14. **Review detailed production (shooting) schedule**

15. **Review contingency plans**, if applicable (global pandemic, political unrest, etc.)

16. **Review eco-friendly production**/sustainability measures, if applicable

Offline Edit Review Meeting (Post-Production)

Purpose

To review rough videos or versions of commercials with the agency, obtain client feedback for approval/revisions, and receive further direction toward finishing the spots.

Timing

Approximately one week after the shoot.

There may be several rounds of this type of meeting asking for approval on the various elements of a commercial.

Key Discussion Points

1. **Vision.** Discuss overall creative vision provided by the agency creative team.

2. **Approach.** Identify any new approach to the commercial, including special effects, music, graphics, and animation. (Timing: transitions, type animation, VFX).

3. **Music/sound design.** Discuss music and sound-design direction. Discuss *licensed music* costs and negotiation strategies, if applicable.

4. **Talent.** Review upgrades, downgrades, and outgrades.

5. **Approvals.** Confirm that you have received all necessary approvals to date.
 a. Identify items previously approved.
 b. Identify what specific elements are being reviewed during the meeting.

 c. Identify specific elements which cannot be changed moving forward without additional costs.

6. **Next steps in process.** Discuss appropriate next steps, what approvals will be expected, and how this affects schedule and budget.
 a. Additional rough-cut approvals
 b. Animation or visual effects—identify steps for approvals
 c. Color correction/color grading
 d. Music production
 e. VO record, sound design, final mix
 f. Conform and finishing

7. **Schedule.** Review completion schedule.
 a. Have there been any changes or marketer input that impact schedule?
 b. Integrate senior-level management and third-party/partner/celebrity approvals.

8. **Budget.** Confirm available budget. Have there been any changes or marketer input that will impact budget?

Post-Mortem Meeting Agenda

Purpose

The purpose is to be able to answer the following:

▸ What went right on the production that we can repeat again?

▸ What went wrong on the production that we should avoid in the future?

▸ What should be done differently next time to enhance the process?

Timing

To be held at the end of the production, after materials have been shipped for distribution (approximately one week after final approval).

Key Discussion Points

Overall Schedule and Budget

▸ Did the schedule allow enough time for bidding, production, editorial, and client approvals?

▸ Did the schedule affect the budget?

▸ Were overages communicated timely, clearly, and effectively? Was there pressure to approve?

Director/Photographer and Production Company

▸ Was the director/photographer enthusiastic to work on the project?

▸ Was the director/photographer collaborative with agency and marketer?

▸ Was the key message clear in the work, or did the execution detract from the work?

▸ Did the director/photographer successfully tell the story in the allotted time frame?

▸ Were your boards shot? Did you have to give up shots due to timing constraints?

▸ Were the branding expectations met?

▸ Was the product handled correctly?

▸ Did you like the camera techniques (angles, movement, etc.) and lighting style used?

▸ Are you satisfied with the casting and actors' performance?

▸ Did the production company provide good value for the money spent?

▸ Would you work with this production company and director/photographer again?

Preparation and Flow of the Day

▸ Did the producer effectively address questions and requests from agency and marketer?

▸ Was the schedule for each day of the shoot communicated sufficiently?

▸ Was the agreed-upon schedule followed? If not, why?

Location

▸ Did the location serve the creative and represent the marketer's culture?

▸ Could the location be used for future projects?

Props and Wardrobe

▸ Was the marketer able to provide product list to agency early in the process for timely sourcing?

▸ Was marketer able to provide product for the shoot?

▸ If not, were there any issues sourcing product?

Post-Production

▸ Did the editor deliver the creative vision?

▸ Did the editor bring more to the project? Did they improve the board?

▸ Did the agency/editor respond to the marketer's feedback creatively and timely?

▸ Was there enough time in the editorial schedule for marketer approvals?

▸ Did delays in editorial approvals cause overages?

▸ Was the editorial company able to successfully handle marketer volume?

Other:

▸ Were there any other learnings from this production regarding DEI&B, sustainability, contingency plans, etc.?

Final Thoughts

From answering the questions listed above, please expand on key victories and pain points.

- ▸ Pain Point 1

- ▸ Pain Point 2

- ▸ Pain Point 3

- ▸ Victory 1

- ▸ Victory 2

- ▸ Victory 3

Notes

"buh-bye"